This appeared in the *Illustrated London News* of 21st February 1852

# THE SHIP PAINTERS

Also by Roger Finch:

COALS FROM NEWCASTLE

*The Story of the North East Coal Trade
in the days of sail*

# THE SHIP PAINTERS

by

## ROGER FINCH

TERENCE DALTON LIMITED

LAVENHAM . SUFFOLK

1975

Published by
TERENCE DALTON LIMITED
ISBN 0 900963 25 5

*Printed in 11/12 pt Baskerville Typeface*

0900963255

Printed in Great Britain at
THE LAVENHAM PRESS LIMITED
LAVENHAM      .         SUFFOLK

# Contents

Acknowledgements .. .. .. .. .. .. .. 6

Introduction .. .. .. .. .. .. .. 9

Chapter One       Early Nineteenth Century Painters .. .. 12

Chapter Two       Later Ship-portraitists .. .. .. .. 31

Chapter Three     Across the North Sea .. .. .. .. 46

Chapter Four      Origins of Style .. .. .. .. .. 56

Chapter Five      Identification .. .. .. .. .. 66

Historical Review .. .. .. .. .. .. 73

Biographical Notes on Ship-Portraitists .. .. .. .. 123

Glossary .. .. .. .. .. .. .. 130

Bibliography .. .. .. .. .. .. .. 133

Index .. .. .. .. .. .. .. .. 134

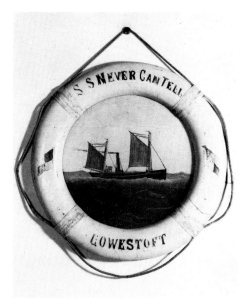

Lifebuoy picture by G. Race, 1906. 11 ins. diameter.          *Robert Malster*

# Acknowledgements

Gratitude must be expressed here for the help given to me in the creation of this book. I owe an especial debt of gratitude to Robert Malster for his early encouragement, to James Wilson of the Sunderland Museum and Art Gallery and Simon Carter of the Simon Carter Gallery, Woodbridge.

The following have also assisted in providing illustrations and furnishing information without which the value of much that appears here would be infinitely less: Peter Barton, Hervey Benham, Michael Bouquet; Charles Lewis, Great Yarmouth Maritime Museum; E. W. Paget Tomlinson, Hull Museums and Art Galleries; Ipswich Museums; Robert Trett, Kings Lynn Museum; John Lewis; A. M. Cubbon, Manx Museum, I.O.M.; M. K. Stammers, Merseyside County Museum; John F. C. Mills; Dan Lailler, Musée de Saint Malo; Hugh Moffat, E. H. Archibald, National Maritime Museum; D. Morgan Rees, National Museum of Wales; J. van Beylen; National Scheepvaart Museum, Antwerp; Nottage Institute, Wivenhoe; Daniel Hay, Whitehaven Museum; R. Smith, Glasgow Museum and Art Gallery; W. Salmon, Lowestoft Maritime Museum.

And lastly but no means least David Wood for his painstaking photography and Marjorie Smith for her patience and care in assisting in the preparation of the manuscript.

Roger Finch,                                                                                    October 1975.
Ipswich.

"Bark or Barque". Illustration from the nineteenth century book *Sailing Vessels.*          *Author*

# Index of Illustrations

Name of artist, where known, is shown in brackets. A 'C' preceding the entry indicates a fine colour picture. The remainder are black and white.

| | |
|---|---|
| Lifebuoy picture (G. Race) ... .. 5 | C *Carisbrooke Castle* (A. de Clerk) .. 60 |
| Bark or Barque .. .. .. 6 | C *Southern Belle* (A. de Clerk) .. 60 |
| Lifebuoy painting (G. Race) .. 11 | C *Lion* (J. Fedi) .. .. .. 61 |
| Brig *Caesar* .. .. .. 13 | C Brig *Eliza* of Yarmouth .. .. 61 |
| Chasing the smuggler (Joy) .. .. 14 | Packet-ship *Ben Nevis* .. .. 62 |
| Hull Whalers (T. Binks) .. .. 15 | Barque *Mindora* (J. Stewart) .. 63 |
| Brig *Andromeda* (M. Walters) .. 16 | C *Brothers Friend* (A. Lamaetiniere).. 64 |
| *Christian* (R. Salmon) .. .. 17 | C *Reform* of Plymouth .. .. 64 |
| Ship *Erato* (S. Walters) .. .. 18 | A Brig .. .. .. .. 65 |
| Barque *Casma* .. .. .. 19 | Barque *Quos* (W. L. Alfreds) .. 67 |
| Seaman's chest lid .. .. .. 19 | Barque *Windrush* (E. Wilkinson) .. 68 |
| *Neva* (V. Luzzo) .. .. .. 21 | Ship *Alcester* of Liverpool .. .. 69 |
| *Grange* (M. Fondo) .. .. 22 | Brig dated 1814 (H. Collins) .. 72 |
| S.S. *Rosemount* .. .. .. 23 | C *Princess* (R. Chappell) .. .. 74 |
| *Visitor* (N. Cammillieri) .. .. 24 | C *Ulelia* (R. Chappell) .. .. 74 |
| Ship *Le Mars* (F. G. Roux) .. 25 | C YH 779 (T. Swan) .. .. 75 |
| Brig *Wulfran* (F. G. Roux) .. 26 | C *William* .. ... .. 75 |
| Barque *Harmonier* (M. A. Roux) .. 27 | C Brig .. .. .. .. 75 |
| Brig *Wonder* (H. Pellegrin) .. 28 | *Acasta* (M. Walters) .. .. 76 |
| Brig *President* .. .. .. 30 | *Whaler in the Arctic* (R. Willoughby).. 77 |
| *Harwich* (R. Chappel) .. .. 32 | C YH 997 (Mowle and Luck) .. 78 |
| *Britannia* (R. Chappell) .. .. 33 | C LT 471 (G. Race) .. .. 78 |
| *Enterprise* (R. Chappell) .. .. 34 | C *Hunter* YH 560 (T. Swan) .. 78 |
| *Bona* (J. H. Mohrmann) .. .. 36 | C *Maria* (G. Fedi) .. .. 79 |
| *Eilbek* (J. H. Mohrmann) .. .. 37 | C *Fortitude*, Ipswich .. .. 79 |
| *Sleet* YH 717 (T. Swan) .. .. 38 | *City of Carlisle* (E. Poulson) .. 80 |
| *Rescue* (G. V. Burwood) .. .. 39 | *City of Hamilton* (W. Webb) .. 80 |
| Drifter *Renown* (P. Gregory) .. 40 | *John Scott* 1837 (J. Heard).. .. 81 |
| Brig *Corcyra* (J. Fannen) .. .. 42 | *John Cobbold* (N. Cammillieri) .. 82 |
| *Star of Hope* (G. Laidman) .. .. 43 | Brig *Linnus* .. .. .. 82 |
| *Sint Johannes of Trondhjem* .. 46 | Brig *Mary Brack* (N. Cammillieri) .. 83 |
| *Tagus* (B. H. Hansen) .. .. 47 | *Rapid* of Ipswich .. .. .. 83 |
| Snow *Triton* (J. Petersen) .. .. 48 | Brig *Florence* .. .. .. 84 |
| *Elvira* (J. Petersen) .. .. 49 | *Renard* (J. H. Loos) .. .. 84 |
| Brig *Viking* (H. Loos) .. .. 50 | *Anne Duncan* (W. M. Yorke) .. 85 |
| Schooner *Thetis* (P. Weyts) .. 51 | *William* .. .. .. .. 85 |
| *Alarm* (B. H. Hansen) .. .. 52 | *Meda* (E. Wilkinson) .. .. 86 |
| *Joshua Nicolson* (J. H. Mohrmann) .. 53 | Barque *Orwell* .. .. .. 87 |
| *Princess Alice* disaster .. .. 55 | *Red Rose* (Captain Paulson) .. 88 |
| *Owen Glendower* (T. G. Dutton) .. 56 | Barque *Esther* .. .. .. 88 |
| C *Wilshere* .. .. .. 57 | *J. M. Kirby* .. .. .. 89 |
| C Brig *John* (R. Nibbs) .. .. 57 | *Villata* .. .. .. .. 89 |
| *Emily* (W. A. Knell) .. .. 58 | |

| | |
|---|---|
| *Flying Childers* (J. Scott) .. .. 92 | *Thomas and Elizabeth* (R. Hord) .. 108 |
| *Craigmullen* (W. L. Alfred .. .. 93 | Schooner *Snowdrop* .. .. 109 |
| *Deva* (H. Percival) .. .. 93 | *Charles Henry* (J. Hudson) .. .. 109 |
| *Courier* (N. Cammillieri) .. .. 94 | *Thomas* of Whitehaven (J. Whitham).. 110 |
| Rescue of crew of *Alice* of Bath .. 94 | *Earl* 1854 .. .. .. .. 110 |
| *Northumberland* (W. Broome) .. 95 | S.S. *Florence Nightingale* .. .. 111 |
| *Genesta* (J. Farnen) .. .. 95 | RE 197 .. .. .. .. 111 |
| *Stockwell* (H. May) .. .. 96 | *Dawn of Day* LT 565 (G. V. Burwood) 112 |
| *Rozelle* of Glasgow .. .. 96 | *Leslie* LT 186 (G. Tench) .. .. 112 |
| Unknown ship (J. Harris) .. .. 97 | *Sir John Colomb* YH 218 (T. Swan) .. 113 |
| *Elizabeth Nicholson* .. .. 97 | *Laverock* YH 314 (T. Swan) .. 113 |
| *Vanora* .. .. .. .. 98 | *Flamingo* GY 1021 (F. Ruyers) .. 114 |
| Sloop *Thomas* .. .. 98 | *Loch Lomond* A 857 (H. H.) .. 114 |
| *Eliza* 1891 (J. Fannen) .. .. 99 | *Morrison* YH 78 (T. Swan) .. .. 114 |
| Smack *Clyde* (A. K. Branden) .. 99 | *Rescue* of Guernsey (S. Walters) .. 115 |
| *Empress of India* .. .. .. 100 | *Glance* (H. B. Carter ?) .. .. 115 |
| *Record Reign* .. .. .. 100 | *Raven* .. .. .. .. 116 |
| *James Bowles* .. .. .. 101 | Four-masted barque *Holt Hill* .. 116 |
| *Bona* (J. H. Mohrmann) .. .. 101 | Unidentified barque (T. G. Purvis) .. 117 |
| *Compass* .. .. .. .. 102 | *Principality* .. .. .. 117 |
| *Pride of Mistley* .. .. .. 102 | *Cedarbank* .. .. .. 118 |
| *James R. Bayley* .. .. .. 103 | Norfolk Wherry (W. Preston) .. 118 |
| *Edith Eleanor* .. .. 103 | *Willie* of Driffield (R. Chappell) .. 119 |
| *Anna Dixon* (J. Robson) .. .. 104 | *Haste Away* (F. Ruyers) .. .. 119 |
| *Essex Lass* (N. Cammillieri).. .. 104 | *Swift* 1906 (C. C. Hyatt) .. .. 120 |
| *Perseverance* (H. Loos) .. .. 105 | *Mazeppa* (R. Chappell) .. .. 120 |
| Mersey pilot Sloop No. 6 (S. Walters) 105 | S.S. *Gem* .. .. .. 121 |
| Mersey pilot Schooner No. 4 (J. Whitham) .. .. .. 106 | *Seaham Harbour* .. .. .. 121 |
| Lynn No. 1 pilot cutter (G. Laidman) 106 | Schooner rigged steamer (M. Mc-Lachlan) .. .. .. 122 |
| Yawl *Jullanar* (E. Adam) .. .. 107 | *Ruperra* of Cardiff.. .. .. 122 |
| Victorian schooner yacht .. .. 107 | *Competitor* .. .. .. 132 |
| S. Y. *Valhalla* (D. Simone) .. .. 108 | |

# Introduction

THE following pages, an all too limited space to attempt to span such a wide subject, are devoted, unashamedly, to exploring, explaining and, one hopes, communicating a personal enthusiasm. It is an enthusiasm for ship-portraits, particularly those known to seamen as "pier-head paintings" whose possession was a source of pride to them for generations. It is to be hoped that neither those who rapidly become bemused with talk of flying jib-booms, upper-topsails and futtock-shrouds, nor those who dismiss an art that makes representation a declared and primary aim, will be deterred from reading further. There is much more to sailing ship portraits than this; nostalgia may be part of their attraction, but their value and the pleasure they give extend beyond an ability to evoke a past made desirable with the passage of the years.

To simplify matters I have divided the book into three sections, each with its own approach, although inevitably they will overlap and complement one another. The object of the first section is to outline the development and variety of European ship-portraiture and to unravel the pictorial tradition of the *genre* from its beginnings in the early years of the nineteenth century and its origins at an earlier date. This is not, it must be emphasised, yet another analysis of the marine painting of the academies and commendatory commissions with their endless Trafalgars, *Royal Georges* and equally royal Cowes. They have had ample scholarly attention elsewhere. The paintings selected for reproduction and commentary here were nearly all produced for, and indeed sometimes by, the captains, owners and crews of the ships themselves; they are representative of almost every build and rig of one of man's most beautiful creations, the sailing ship. China clippers, steel windjammers, wooden sailing drifters and many more were all recorded in this way in varying and individual styles. It is a tradition of painting which has now, but only relatively recently, reached its end, starved by steam and killed by the camera.

Augmenting this account is a tentative reference list giving biographical details of some of the journeymen artists who painted the pictures. It is by necessity incomplete. The proportion of unsigned work that has survived and defies attribution, is high. One is humbled, for instance by the fact that the delicate work by Chinese artists who painted ships for European patrons visiting Eastern seas, must in all likelihood remain forever anonymous. The painter who produced the evocative picture reproduced on the dustjacket, its companion in the Historical Review and the portrait of the *Raven,* despite a colourful and distinctive style and much searching, remains obstinately unidentifiable.

The motive behind the commissioning of the paintings lay in what has been defined as a "metaphorical act of appropriation"; the owners identified themselves

with the subject, an identification which in turn was an expression of justifiable pride and involvement. One should not forget that prior to the camera's general use, and that, as far as the sailing-ship was concerned, did not occur much before the end of the nineteenth century, only paintings and painters offered recorded evidence of how objects appeared. Fortunately for us, because of this, actuality, suitably tempered by idealisation, was the keynote of the ship-paintings.

Besides the art and the artists there is a third aspect of the pier-head paintings that demands consideration. As we study the set of the sails, the line of the hull drawn with such care and the distant coastline with its accompanying shipping recorded so long ago with such deliberation, we are prompted to ask questions. What was their place in the scheme of the seafaring world they inhabited with such conviction? How was such an individual wooden world created and how could something so vulnerable survive the savage sea? To attempt to answer these questions I have used the paintings as points of reference to outline an account of the sailing ship during the nineteenth century, giving perhaps special emphasis to the smaller vessels, when evolution was rapid and changes far reaching. These complex technical changes are excellently illustrated by the pictorial records that the ship-painters made and provide an invaluable aid to their understanding. The inclusion of this miniature history requires, I feel, no apology, for the paintings themselves were intended first and foremost to be descriptive and to be records of fact. The artists were deeply involved with the particular vessel rather than woolly generalisations and inevitably produced an historical record of charm and considerable value to our own generation. The materials used in their production were perforce of the cheapest and therefore tended to be impermanent; their conservation, once those who were immediately associated with them had passed on, was all too often perfunctory in the extreme. One painting reproduced here was rescued from a pig-sty, while another was found trodden underfoot in a flooded building! Yet these faded water-colours and cracked canvases can contribute unique evidence of a lost way of life and the complexities of trade under sail.

Those fortunate enough to have inherited, or are collectors of "pier-head paintings" are inevitably interested, and rightly so, in the associations and history of the vessel depicted; her owners, her voyages and commanders. The paintings may show a wide differential of talent but all have an element of unpretentious honesty. The ship, whether it is storm-tossed or ghosting along under full sail across a painted ocean, invites questions; I have tried to provide some signposts to assist in providing answers.

The recent re-appraisal of the art of the Victorian age has widened, as it should, to include the robust popular-art of the nineteenth century. It is the popular art of an industrial age and ship-portraiture is a lively and colourful part of it, although its roots extend to a period and tradition before Victorian times.

Museums throughout the Western world are becoming increasingly aware of the value and interest of ship-portraits of a humbler sort as part of our heritage. There is irony in the fact that, even when one makes adjustments to allow for changes in monetary values, the prices which the work of pier-head artists now fetch in the saleroom is at least one hundred fold the few shillings that the majority received at the quayside from their seafaring patrons. A chosen few artists have far exceeded even this scale of appreciation.

One is tempted to ask why many chose a livelihood so precarious and ill-paid. Perhaps for some practitioners painting ship-portraits was a way to cling desperately to the fringes of respectability; for others it was a craft to be followed honestly and well, often perpetuating a family tradition, a welcome alternative to being drawn into the remorseless discipline of nineteenth century industry. Some, I am sure, found in their work a genuine delight in the opportunity it afforded for self-expression and to earn a well-deserved esteem in their community. I hope that this book may provide some modest if belated recognition to them all.

*Note.* The titles provided for the paintings are in most cases either those inscribed upon the work itself by the painter or upon the original frame or, in a few cases, on the reverse of the picture. These titles are indicated by single quotes. When these were not available a title has been provided from evidence derived from the painting itself and references to records. It is regretted that in many cases areas of the pictures not relevant to the central subject have been excluded. Care has been taken that this has not drastically altered the balance of the painting and nothing of interest has been lost. In a few cases the original painting has not been available for examination and dimensions have been omitted.

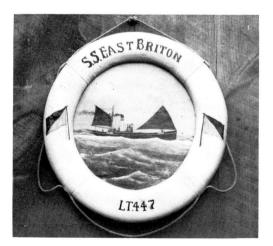

Lifebuoy painting by G. Race, 1921. 11 ins. diameter.

# Early Nineteenth Century Painters

To those who know the sea, a ship-portrait of any age, in any style, makes an immediate appeal. In these pages it is hoped to bring into focus, with the assistance of an anthology of their work, the hitherto neglected work of the later painters of ship-portraits, particularly those of the smaller trading vessels. They were those who strove with a striking honesty of purpose, if at times a lack of imaginative vision, to record sailing vessels and the earlier steamers for the men who served aboard them and owned them. Their interpretations were various: matter-of-fact, romantic, narrative, naive, even lyrical, but their success hinged upon their acceptance by those who commissioned them — masters, mates or owners.

In the seventeenth century, when ship-portraits first began to appear, the patrons were largely naval officers. Paintings of merchant-men are rare. The next century saw an increasing number of East Indiamen, pre-eminent amongst the commercial fleets portrayed by artists, and yachts maintained by Royalty and the aristocracy appeared on canvas at the behest of their affluent owners; however, portraits of smaller vessels, although not unknown, only rarely survive. At the freeing of the seas with the successful conclusion of the Napoleonic Wars (when a diminution of naval engagements removed a favourite subject of maritime artists) the rapid increase of shipping and ship painters saw every type of rig and vessel depicted, until by the 1850s one can find the whole spectrum of shipping displayed in picture form.

The artists who produced this flood of work may not rank with the great exponents of marine art on the grand scale of the eighteenth century, master-artists of the calibre of Brooking, Serres or Pocock. Nor did they use the recipes or apply the conventionalities of the Victorian marine painters with their glossy canvases of epic proportions. They were artist-craftsmen who were rarely celebrated beyond the circle of their patrons. Despite their limitations, their paintings were animated with a personal style and an affectionate attention to detail enlivened by a vigorous treatment of the subject, all factors which now endear them to collectors and museums. Many are the work of anonymous artists. It is more than probable that the majority of the unsigned paintings reproduced in these pages whose artists are unknown, were the work of artisans; house-painters, sign and carriage-painters or even aspiring amateurs who never achieved full-time professionalism. Their work has a certain quality that the more sophisticated ship-

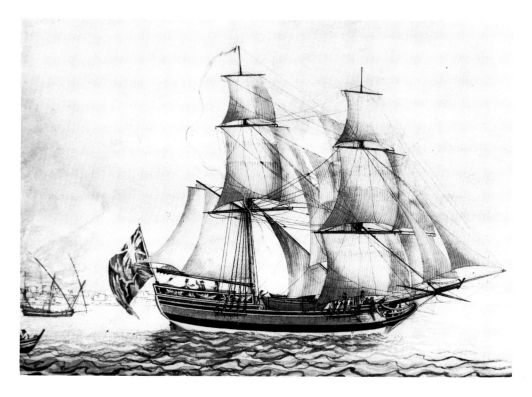

*The Brig Caesar, 1788*  *Water colour*  *Manx Museum*

The painting is inscribed with the title '1788 The CAESAR, Captain William Stowell' and is a rare example of an eighteenth century ship-portrait showing a small merchantman, and originates from Naples. Good fortune has preserved the vessel's account book and we can trace the details of the voyage which took her to the Mediterranean so long ago for her Manxman owner, John Joseph Bacon and where, on her arrival, the picture was painted.

The *Caesar*, named after an Isle of Man family, was built at Douglas in 1783 by Mathias Kelly. She sailed from Douglas in October 1788 with a cargo of the Isle's staple produce, six hundred and fifty-seven barrels of red-herrings. The little brig cleared for the Mediterranean from Liverpool a few days later. The skipper received £6. 8. 4d. 'primage', a perquisite, while the crew of five shared a more modest 'Hospital money' of thirty-four shillings and five pence. A safe return to Liverpool showed a handsome profit, one of a series, for earlier charters had been to Nice, and although of only a very modest tonnage she had voyaged in 1787 to the West Indies, returning with rum and sugar. Although a prosaic cargo, the red-herring in barrels from British herring ports to the Mediterranean brought prosperity to merchants and produced fine ships; profits that might be made from a successful voyage encouraged commanders and share-holders to commission paintings.

The *Caesar* is shown fitted with canvas screens protecting the poop, painted in contemporary style, while she has no bulwarks, or even rails, to protect the deck amidships. She is a true brig, with no trysail-mast abaft the lower main-mast, and she sets a 'ring-tail' as an extension of the driver, besides an ample spread of stunsails.

portraits seem unable to convey. Instinctively, without theorising, they realised that art is not the photographic copying of detail, but the creation of a pictorial equivalent for nature linked with an innate gift for simplification.

It must be admitted that it is almost impossible to determine precisely where the work of the academically trained, who turned to marine art is divided from that of the anonymous who, with little formal instruction, advanced rapidly from the class of journeymen painters with a limited seafaring patronage, to a position where they could confidently command the attention of the wealthy and educated. Naturally these men were more numerous during the later decades of the eighteenth and the opening years of the nineteenth century, before painters were trained in schools of art and when a form of apprenticeship could still provide the first steps towards a career as a professional artist.

Amongst those who, after a humble beginning, later in their career shed a vernacular awkwardness and attracted the attention of those whose taste was formed in the mainstream of contemporary culture, were such men as R. H. Nibbs (1816-93). Nibbs began as a ship-portraitist when still in his teens and yet by his mid-twenties was exhibiting marine studies at the Royal Academy. Others, all of an earlier generation than Nibbs, were the brothers William and John Cantiloe Joy of Yarmouth (William 1803-67, John Cantiloe 1806-66), Robert

*Joy 1855*          *Water colour*          *10½ x 13 ins.*

Chasing the smuggler. The brothers John and Cantiloe Joy produced animated paintings such as this, although their later pictures can be most unimaginative. The collier-brig to windward and the Revenue cutter, with its topmast struck and squaresail yard hove down, were both craft which the artist knew well from earlier years at Yarmouth.

*J. N. C. Lewis*

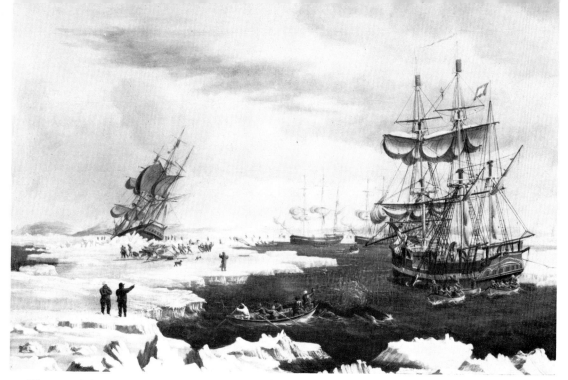

*Thomas Binks*            *Oil on panel*            *18 x 25 ins.*

Hull Whalers in the Arctic 1822. Binks was determined to include on a single crowded canvas every aspect of the Arctic whalers' perilous existence. The fishing season of 1822 was a bad one and while all the Hull ships returned others were not so lucky and seven whalers ended as the one shown, high on the ice pack, their crew seeking refuge in other ships. The whaler moored to the ice is flensing - cutting the blubber off the carcase of a whale.

*Kingston upon Hull City Council, Ferens Art Gallery*

Salmon born at Whitehaven in 1775 and James Ward of Hull (1798-1849) who began as a 'prentice house and ship painter.

These men had the advantage of working in ports which were expanding with the flood-tide of nineteenth century commercial activity. Fortunes were being made (and lost) in foreign trade and ship-owners were not averse to displaying evidence of their newly found wealth on the panelling of their counting houses and homes. More important, from the ship-portraitist's point of view, they were, as yet, still proud to advertise unashamably the commercial origin of their success. Newly launched vessels were celebrated with a painting, recording every detail from the gilded truck on the mast-head to the boot-topping on the water-line, and having proved its financial profitability, an older ship would be similarly recorded, flags flying and every sail drawing.

Whaling ports, such as Hull and Whitby, where successful voyages to the Arctic made a sizable profit, might well provide not only captains and owners but

crews as well, with dividends which left a margin to be invested in a modest pictorial display of their good fortune and evidence of their hardihood in the frozen Northern seas. John Ward was only one of a group of Hull painters who provided a telling graphic record of the whale-fishery. Individual whaling ships gathered around them a reputation for good fortune or ill-luck, exceptional even amongst sailing-vessels. One which brought home successive good catches was recorded again and again. An earlier Ward, William (1761-1802) was actually part-owner of a fleet of whalers and recorded his ships. Thomas Binks (1799-1852), Robert Willoughby (1768-1843) and Thomas Fletcher, all working at Hull, began as house or sign painters. However, it should not be forgotten that the eighteenth century apprentice to these useful trades was expected, upon the completion of his training, to be competent in a wide range of skills and techniques, such as grinding colours and preparing grounds which were applicable to the basics of fine art (at the time) and eased their transference into the more genteel field of easel-painting. These artists worked with a sure confidence when dealing with technical details in a manner born of first-hand experience. Ward and others had not only

| *Miles Walters* | *Oil on canvas* | *17 x 23 ins.* |

The Brig *Andromeda*. Undated. The painter has used the eighteenth century convention of including a stern view of the same vessel on a single canvas. She is a typical, heavily rigged brig of the early nineteenth century with quarter windows, immensely long head-gear and a boat carried out on davits over the stern, suitably lowered to tow astern in the smaller of the two representations so that the name *Andromeda*, Hull may be clearly read on the stern.

*Kingston upon Hull City Council, Ferens Art Gallery*

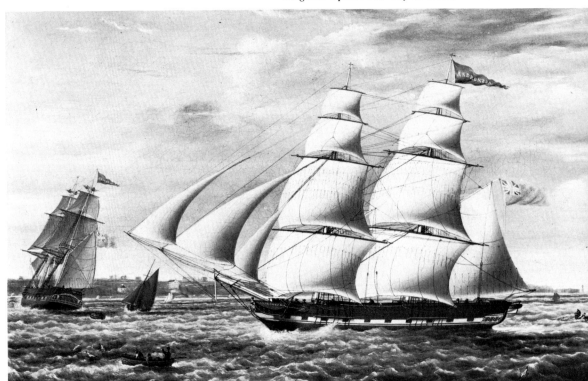

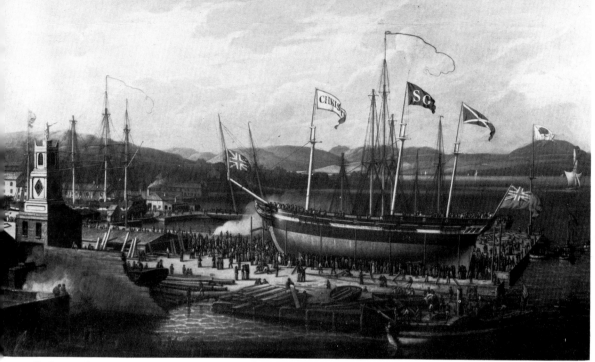

*Robert Salmon*                    *Oil on canvas*                    *22 x 36 ins.*

Launch of the *Christian* 1818. Salmon's painting of a launching from John Scott's original yard at Greenock in 1818 gave him an opportunity to combine his talents for ship-portraiture and topography. The relatively short, deep hull of the early nineteenth century merchantman and the pioneer steam paddler in the foreground are worthy of note.

*Glasgow Museum of Transport*

been to sea but had made voyages to the Arctic. None of this Hull group made an early and entirely successful transference to a different and more lucrative idiom in the way that Ward contrived. Ward achieved an unstudied elegance in his painting and lithographs, while Richard Nibbs (mentioned earlier) and the two brothers Joy, later transferring from Yarmouth to Portsmouth, managed to retain a salty liveliness in their work in both their oil and water-colour paintings. They all moved, by middle life, into a world where commissions for paintings were secured from aldermen, prosperous bankers and merchants, rather than seamen and skipper-owners. Prints were made of their paintings and greatly widened the circle of their contemporary admirers. But, nevertheless, they all avoided the generalised mid-Victorian sentimentality of their more formally trained competitors.

It is hardly surprising to discover that the port of Liverpool, which quadrupled its population in the opening decades of the nineteenth century, supported a major group of ship-portraitists of more than ordinary stature. No less than three generations of the Walters family recorded the ever-increasing shipping of Liverpool, a city which established its own Marine Academy in the early nine-

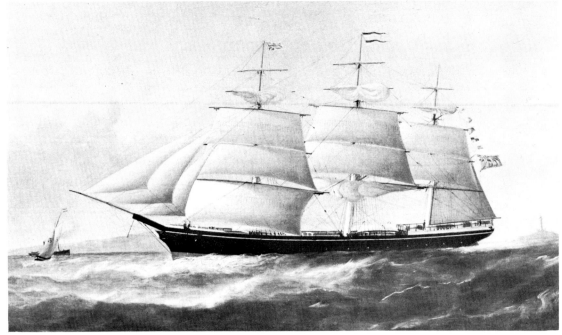

*Samuel Walters (1811-82)*          *Oil on canvas*

Ship *Erato*. A typical example of the artist's work. The *Erato* is representative of one of the iron-built ocean-going ships of the third quarter of the nineteenth century; she was built in 1864 at Ramsey, Isle of Man, of 1205 reg. tons. The hull is pierced with port-holes and indicates she carried emigrants.          *Simon Carter Gallery*

teenth century. The Walters produced ship-portraits spanning the years from the beginning of the Napoleonic Wars until the eighteen eighties, by which time, with a revolution in technology afloat, steam and steel were in the ascendancy and the successful individual owner, who was the mainstay of the ship-portraitist, was becoming a rarity.

This family had humble beginnings. Miles Walters (1774-1849) was apprenticed as a shipwright and served before the mast, eventually reaching a position of command. He was assisted in some of his marine-portraits by his son Samuel who had the unique distinction among these ship-painters recorded in these pages in having been born at sea. Samuel Walters (1811-82) was the most prolific of the trio and examples of his work may be found in galleries throughout the world. Such was his output that he required the assistance of his son George Stanfield (1838-1924) to maintain it. However, George lived to see the end of the tradition of lively ship-portraiture that his father and grandfather had pursued with such characteristic directness and energy. He moved from Liverpool to the South of England and exhibited paintings at the Royal Academy but alas, paintings whose subject matter, treatment and technique were drawn from the common stock of mid-Victorian naturalism.

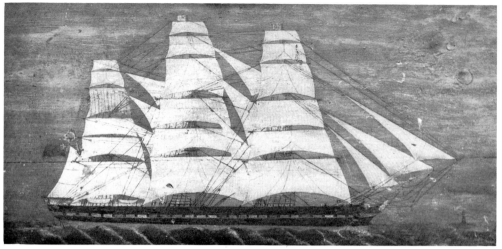

*Anon.*                                        *Oil on canvas*

Barque *Casma*. This sailor-painting of a Liverpool barque of 1869 lacks the sophistication of technique and style so obvious in the work of the Walters. Yet it has qualities of individuality and design which surpass the professional painting and mark it out as a genuine work of art.

*Simon Carter Gallery*

*Anon.*                *Oil on wood*                *(probably from seaman's chest lid)*

The untutored painting by a seaman on his sea-chest lid can carry a conviction unknown on many more carefully painted canvases. This may be tentatively dated from the eighteen seventies. Some such sailor-painters graduated to become ship-portraitists.

*Lowestoft Maritime Museum.*

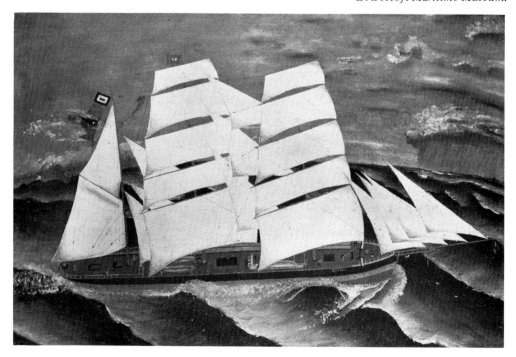

Miles Walters' ship-portraits might display more nautical knowledge than subtlety and his backgrounds usually make specific reference — somewhat naive and artlessly topographical — usually to the Mersey, but they have a decorative and forthright quality. Samuel Walters' work is more sophisticated. His seas and lighting effects show the powerful influence of the Romantic Movement in the academic art of the previous generation; this was the time which it usually took for a change in style to percolate downwards to the *genre* painters. Samuel and George Walters at once established and perpetuated a style which became a standard approach for ship-portraiture not only in Britain but in America.

It was, however, Robert Salmon who, although born in Whitehaven and one of a modest school of ship-portraitists working there, stemming from Henry Nutter (1758-1808), found a well-earned patronage on both sides of the Atlantic. Robert Salmon's career as a painter was divided into two equally prolific periods. The first was spent successively in Whitehaven, where he was born in 1775, then in Liverpool, Greenock and North Shields, painting ship-portraits, early yachts as well as merchant-men and occasionally essaying a topographical or landscape study. Some idea of the scale of his remuneration at this time, not atypical from the earnings of his contemporaries, may be judged by the fact that in 1811 he recorded in his journal "finished June 10 ship Neptune & view of Greenock large £15.15". In 1828 Salmon, a confirmed wanderer, decided in mid-career to try his fortune in the United States. He settled in New England, at Boston, where he lived and worked for years in a boat-builder's shed on one of the wharves — a hut equipped with a studio on an upper-floor and a bow-window which looked out upon a wide view of Boston harbour and its shipping. Salmon can scarcely be said to have made a fortune from his brush. He seldom received more than the equivalent of fifteen pounds for a single canvas and he was not above augmenting his precarious livelihood with sign and scenery painting. His skill in persuading a boat-builder to accept an example of his work in part-payment and then engineering a similar arrangement with a local sail-maker I can only record with considerable envy. In 1842 it is believed that Salmon, his eye-sight failing, resumed his wanderings, returned to Britain and died a few years later, although the exact date and place are unknown.

Robert Salmon's approach was firmly in the eighteenth century tradition. His waves march relentlessly across the canvas with the mechanical precision of a classical frieze and we may be sure that he positions each reef-point, grommet and viol-block with exact precision and a firm grasp of the technicalities of canvas and hemp. Any tendency to a dryness in his technique, however, is relieved by an idiosyncratic effect of lighting his subjects which give his paintings an almost uncanny warmth and brilliancy. It is not surprising to learn that Salmon is considered to be one of the small group of artists from Britain who brought to New England in the opening decades of the nineteenth century a different kind of

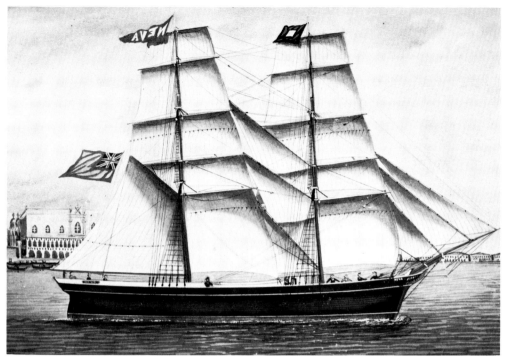

*Vincenzo Luzzo*              *Water colour*              *13½ x21½ ins.*

*Neva* at Venice 1872. The Venetian ship-painters were almost as prolific as those of Naples in the mid-nineteenth century but faded later. The *Neva* was built in 1844 at North Hylton, Sunderland, 295 tons gross, as an ocean trader, yellow-metalled beneath the waterline and re-rigged with double-topsails in the 'sixties.        *Sunderland Museum, Tyne and Wear County*

talent and re-established a long-standing tradition. His patrons demanded of him a verisimilitude and an unexceptional recording of fact; he never disappointed them in this aspect of his work but his exceptional talent elevated his painting to the level of a work of art.

Although Salmon had left behind him, early on in his career, the hills of Cumberland, Whitehaven's growth as a substantial port produced a growing band of ship portraitists. The Lowther family began exploiting the local coal-seams in the seventeenth century and with Ireland as the only potential market a fleet of sailing colliers was rapidly established together with a ship-building industry to support it. The ships assembled to distribute coal, rapidly sought out other less prosaic trades, voyaging across the Atlantic to the West Indies and also the fruit ports of the Mediterranean. These conditions of thrusting local enterprise, rivalry and pride, within a somewhat remote mercantile community, led to a fine flowering of ship-portraiture to produce paintings which were a reflection of it. Henry Collins (fl. 1810) who is considered to rival Salmon, was a contemporary of John Clementson (1780-1844). Oliver Hodgson (fl. 1830-64) and Joseph Heard (1799-1859) probably the best-known of the group, lived long enough to celebrate the

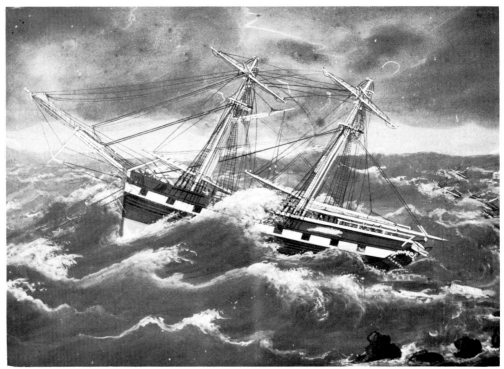

*Michele Fondo*                     *Gouache on paper*                     *18 x 17½ ins.*

*Grange* in a storm off Naples 1848. With topmasts and topgallant masts struck, yards at deck level the Sunderland brig, lying to both anchors, drags perilously close to the rocks. She was launched in 1845 for George Hudson, the Railway King, at Sunderland and survived the storm to trade to Leghorn and North America. Such paintings as these have a close affinity to the Mediterranean 'votive' paintings.                     *Sunderland Museum, Tyne and Wear County*

arrival of steam which they obviously enjoyed painting with the opportunities it provided for novel pictorial effects.

These men were, perhaps, limited in their skill and vision. Yet a wide gulf existed between their painting and the work of some of the ship-portraitists whose work is reproduced here and whose painting limits the opposite extremity in expertise in the *genre*. They were tradesmen who occasionally would produce, no doubt employing ship's paint, the lid of a cigar box or a scrap of cardboard from a haberdasher's tray, an energetic picture for a shipmate or seaman friend. It exchanged hands for a pint, or perhaps two, in a quayside pub and while it had a style obviously derived from the professional ship-portraitist, the technique used to produce it lacked the adroit treatment of detail with which the expert enlivened his work. Yet some of these aspiring artists went on to turn the kindness of a moment into a career. John Henry Mohrmann (1857-1916) whose career is dealt with in detail later, began producing ship-portraits which covered a wide range, in this way. Otto Hansen of Sunderland, sailor and shipyard-worker, and the numerous artists who found employment in the fishing ports, were numbered in this group.

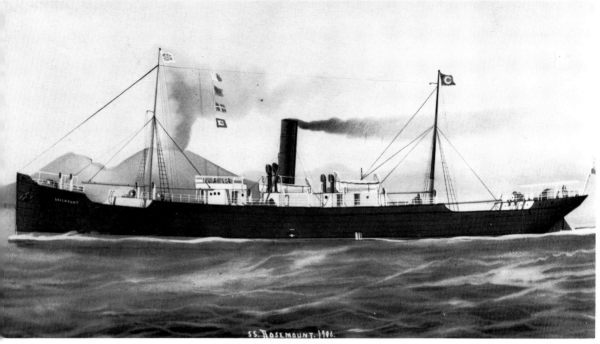

*Anon.*                      *Gouache on paper*                      *17 x 26 ins.*

S.S. *Rosemount* 1906. The traditional ship-portraiture associated with the port of Naples lasted until the beginning of the twentieth century. The *Rosemount*, A Cory collier, is representative of hundreds of steamers which carried bunker-fuel along the Empire trade routes in the days of coal-burning fleets.           *J. Martin*

In Britain these journey-men painters of shipping earned for themselves the name of "pier-head" artists. Tradition had it that they were not too proud to stand at the dock-end soliciting commissions for their brush amongst the motley crowd of old shell-backs, women and wives and unemployed seamen hoping to find a berth at the last moment. They had their equivalent in Denmark where they were called *kadrejerbilleder*. This name derived from the boats known as *kadrejer* in which the ship-chandlers rowed amongst the newly arrived vessels seeking custom. *Kadrejerbilleder* may be translated as "bum-boat pictures". At the ports of Malta, Venice and Naples the ship-painters sought customers aboard the visiting ships of Northern Europe, showing examples of their skill. They collected commissions and sometimes duplicate paintings of the same vessel would be ordered, especially if the ship was newly launched.

The international nature of the art makes a selection of ship-portraits for reproduction in this book doubly interesting. A quarter of a century after the last authentic one has been painted there still survive thousands of examples. Each one, no matter how naive, has its conventions interwoven into a pattern of ship, sea and sky, an absorbing miscellany of past pride and memories, a potent re-

minder of a way of life long gone and a record of the ways of man and the sea. I have restricted the choice, almost entirely, to British registered vessels, but have not confined it to British painters. During the nineteenth century, with growing impetus, the smaller sailing ships of our ports, of so small a tonnage that it seems today barely possible, ranged far and wide, as well as the ships and barques which, to our twentieth century eyes, appear better adapted to ocean voyaging. For the smaller fry to return from Naples or Odessa, Oslo or Pireus, with a painting was proof positive of a long voyage successfully completed and a reminder for loved ones to advertise their commitment. We can, therefore, assemble a miscellany of ship-portraits, both decorative and informative, drawn from half a dozen national traditions.

It has been convincingly argued that the tradition of ship-portrait painting, which in turn stimulated both the *genre* and the demand in Northern Europe, derived from the 'votive' pictures. These examples of simplistic faith are still to be found in Catholic churches from Barcelona to Corfu. They are devotional paintings, usually on wood, commissioned by the whole crew of a vessel to record their miraculous survival from near catastrophe at sea — a survival they considered to be directly due to divine intervention at a moment when all seemed lost. These paintings were placed reverently in churches and chapels upon a happy return.

*N. Cammillieri*                    *Water colour and line*                    *17 x 22½ ins.*

'Schooner *Visitor* of Ipswich going out of Malta Oct. 12th 1846'. Built by Bayley and Co. at Ipswich in 1840 and sheathed below the water-line with zinc, the *Visitor* was a regular Mediterranean trader before being relegated to coasting and finally coming to grief on the Welsh coast. She flies the Masonic pennant on her fore-mast.                    *Ipswich Museums*

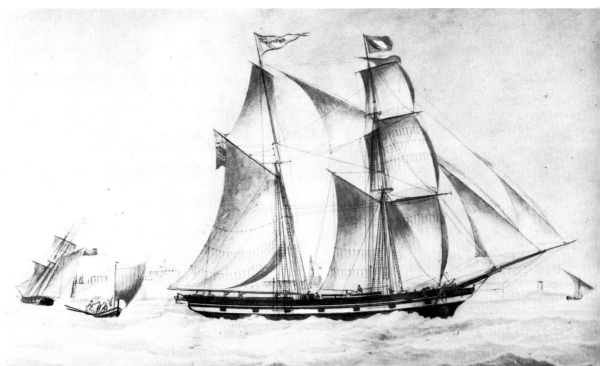

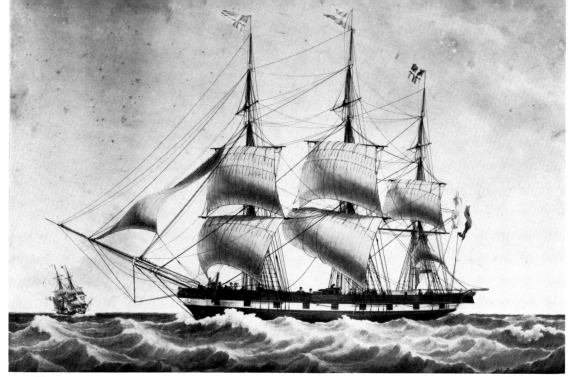

Francois G. Roux                    Water colour
Ship *Le Mars*, Captain Augustine Perrond, Marseilles 1822.          *National Maritime Museum*

Examples, although now worm-eaten, smoke-blackened and flaking, survive from
as early as the sixteenth century, depicting lateen-rigged Venetian galleys. The
paintings become increasingly dramatic and the ships in them more naturalistic
with the passage of time and combine in a rather startling juxtaposition marine
art and religious iconography. A spirited rendering of the vessel in dire distress,
and above, in the area of the darkest clouds, a vignette of a patron saint appearing
in an act of intercession were all included on the same canvas.

The technique developed by Mediterranean painters over the centuries for
the production of these traditional pictures was easily adaptable to the secular
taste and purchasing power of a wider market. This stimulus was provided by the
commanders of the hundreds of small merchant vessels, few more than three
hundred tons burthen and many much less, which crowded into the Mediterranean
ports at the termination of the Napoleonic Wars, reviving a trade dating from the
eighteenth century. Indeed a few ship-portraits, linked to the 'votive' picture
tradition survive from before this time. With little modification it was a *genre*
which survived well into the age of steam and steel, when sail had been all but
eclipsed. The tradition of producing a pair of pictures, one "fine-weather", one

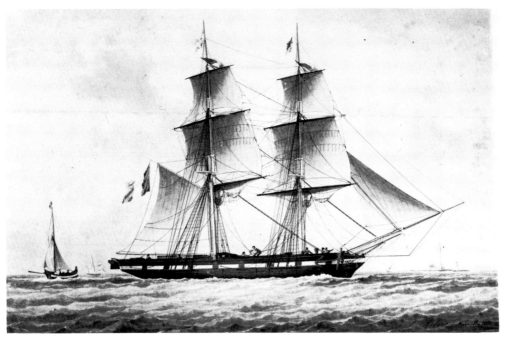

*Francois G. Roux*                    *Water colour*

The Brig *Wulfran*, Captain Gubert, Marseilles 1839.          *National Maritime Museum*

"foul-weather", gave ample opportunity for the painters to use their skills employed in rendering the storm conditions essential to 'votive' pictures. It was only necessary to remove a saint or two to make a picture produced for a Neapolitan, recording his efforts to escape a lee-shore, entirely acceptable to a staunch Methodist captain of a Geordie brig.

The ship-portraitists of the Mediterranean ports, particularly those of the eastern seaboard, produced their work upon paper, using gouache, an opaque form of water colour, with immense dexterity. The medium has rather more in common with oil paint than true water colour as it is understood in Britain, for the opacity of the colour permits the artist to achieve his effects by working from dark tones to lighter ones as the painting nears completion. The technique produces some of an oil painting's richness of colouring with a very considerable economy in time and materials. It must also be admitted that it lent itself, in the hands of the Mediterranean ship-portraitists, to a degree of rapid mass production. Ship-portraitists of both Venice where worked Vincenzo Luzzo, and Naples used it almost exclusively as a medium. The Doge's Palace, the harbour at Leghorn, or the familiar view of Vesuvius smoking beyond the harbour mole and lighthouse at Naples, invariably painted with a charming disregard for scale, set against a cloud-

less blue sky, immediately identify their port of origin. While awaiting orders from skippers the appropriate background could be reproduced in gouache by less skilled hands in little rooms off the streets of the Piazza Goldoni or the Old Town of Naples. Upon the receipt of a firm order, on this prepared background the appropriate vessel could be added, with immaculate detail, by the master-painter in the minimum of time.

Many of these paintings were unsigned. Even when they are, the existence, as in Northern Europe, of dynasties of painters bearing the same name, makes it difficult to unravel the attribution of work. Guiseppe and Joseph Fedi were producing paintings for British captains as early as the second decade of the nineteenth century at Leghorn. At Naples Michele Fondo and Nicola Fonda were working in the middle and latter part of the nineteenth century, and at an earlier date a Cammillieri at Marseilles. Another artist who combined producing 'votive' paintings, or *madonnari* as they were known in Naples, with ship-portraiture, was another Cammillieri, Nicholas S., working in Malta in the mid-century, followed by Georgio D'Esposito.

Nicholas S. Cammillieri did not use gouache, but with a very lively technique achieving his effects by water colour washes combined with an ink line. It is alas, difficult to envisage exactly how they appeared when newly painted, for the

*Mathieu A. Roux*     *Water colour*
French Barque *Harmonier*, Captain J. B. Perreê, Marseilles 1831.     *National Maritime Museum*

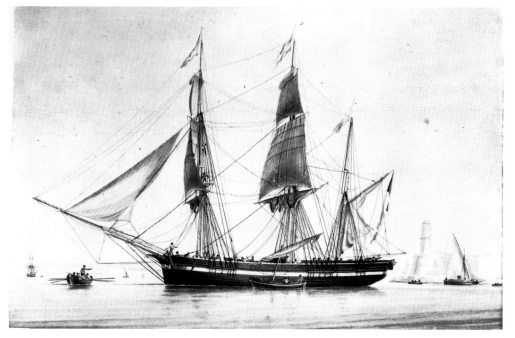

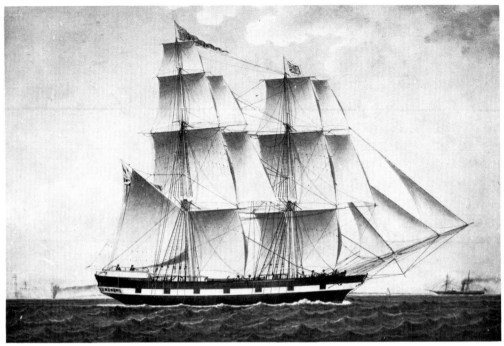

| *Honore Pellegrin* | *Water colour* | *17½ x 22½ ins.* |

'Brig *Wonder* of Sunderland Capt. William Coulson leaving Marseilles Feb.19th 1848'. It would be a mistake to associate Sunderland only with the stubby, begrimed colliers. Brigs like the *Wonder*, built at Stockton, with quarter-windows and a quarter-deck for the captain, a finely carved figure head forward and a full suit of stunsails aloft also hailed from the port. She was later owned at Weymouth and then Blyth whence she traded to the Baltic.

*Sunderland Museum, Tyne and Wear County*

inevitable fading of water colour reduces what were once fresh washes of pigment to grey and sepia tones.

The signatures of Arpe and Cararonne may be found on paintings originating from Genoa. Giovarnni and Vincenzo Luzzo worked in Venice, painting scores of little brigs and schooners sailing by the Doge's Palace on the Lagoon where the giant tankers now edge their way out to sea. Honoré Pellegrin, in nearby Marseilles, was painting ships' portraits in the first half of the nineteenth century, and at the same time working in a more traditional style, Francesco Lengi worked at the port of Malaga. The same style could be found at the eastern extremity of the Mediterranean. At Smyrna (now Izmr) in Turkey, a favourite port during the nineteenth century for British ships to load dried fruit and cereals, Raffalea Corsini produced painstaking portraits of the traders under sail.

Working in their traditional style, immigrant Italian painters, such as Cammillieri, played a significant role in the establishment of the ship-portraitist's trade amongst the captains of humbler commanders visiting Marseilles. However,

it is with the Roux family, whose activities covered nearly a century, that the tradition of ship-portraiture there is chiefly associated.

The family tradition was founded by Antoine Roux (1765-1835) whose heraldic style is more akin to the folk-paintings of his contemporaries elsewhere on the Mediterranean coastline. He was followed by his three sons, all artists, Antoine (1790-1872), Frederic (1805-70) and Francois (1811-82). Antoine Roux, *père*, like so many of the earlier ship-portraitists, combined his more creative work with that of a ships' chandler and chart agent, which no doubt enabled him to place his work, which also included 'votive' pictures, before potential customers. The paintings of the three sons have a sophistication not found in their father's work and an unobtrusive mastery of a naturalistic style which they combined with a deft handling of perspective. They painted in oil and water colour, using the latter in conjunction with an ink line and transparent washes.

Although they painted British vessels if one judges from surviving examples, their patronage was largely from American shipmasters importing valuable cargoes from the West Indies and well able to afford a permanent record of their Yankee clippers, schooners and brigantines. Many examples of the handiwork of the Roux family may be found in collections on the Eastern seaboard of the United States. A wider distribution of their work in North America was provided by the production of excellent aquatints made from their paintings by N. Currier.

The work of the Roux family is exceptional and their range of treatment of the subject-matter unusually imaginative. For instance they convincingly painted vessels in other than the conventional profile view or depicted them shortening or making sail. This approach is rarely met with in the work of their contemporaries. In the eighteenth century it became fashionable to paint a vessel in two or even three positions on the same canvas — an extremely fortunate convention, for at least one view would show the ship stern-on and with its name and port of registry easily decipherable. But by the opening decades of the nineteenth century this happy arrangement was gradually falling out of use, due no doubt to the imperceptible influence of Naturalism. It required the imaginative resource of an unusual ship-portraitist to produce a worthwhile composition and at the same time satisfy patrons who would be quick to notice and resent any inaccuracy. Nor was such exceptional interpretation only reserved for such world-famous vessels as the great four-master *Great Republic*, pride of the mid-century American merchant fleet; diminutive Danish brigs or British schooners received the same sensitive treatment when they were rendered on to paper. It must be admitted that collections of individual pier-head artists' work when exhibited, as they very occasionally are, tend to a certain visual monotony, to be relieved assuredly by study for evidence of a bygone technology, a latent nostalgia and the anecdotes that cluster about them. Inevitably there is a lack of stylistic development, while

the speed at which the paintings were produced and the innate conservatism of the patrons led to repetition rather than innovation. The Roux family, perhaps because they were inheriting a more flexible tradition, although they too produced 'votive' paintings, or because they were persuasive in their negotiations with their customers, contrived to produce a delightful variety, highly wrought without becoming too formally academic.

While paintings of Antoine Roux, *père*, exist from the eighteenth century, ship portraiture was apparently less well served on the Atlantic coast of France. At L'Havre Edouard Adam did a great deal to redress the balance and from 1875-1910 he produced a very wide range of ship paintings and his ability extended to a confident portrayal of widely differing conditions of sea and sky.

*Anon.*                                        *Oil on canvas*

'American brig *President*, 1807'. This very accomplished painting of a vessel clawing off a lee shore shows clearly the details of an early nineteenth century brig. It has been stated that the difference between a brig and a snow lay in the latter having a mast, upon which the hoops of the mainsail run, directly abaft the mainmast proper. However, contemporary titles indicate that, in the nineteenth century at least, the difference lay in the fact that a brig carried a larger driver with its foot extended well beyond the taffrail by a boom.     *Science Museum, London*

# CHAPTER TWO

# Later Ship-Portraitists

DUE largely to the careful research of C. H. Ward-Jackson we have an unusually full account of one of the last and most prolific of the latter-day ship-portraitists, Reuben Chappell. Chappell was born at Hook near Goole, Yorkshire, in 1870. Goole is a creation of the nineteenth century — a canal town founded upon the coal trade; coal that was brought down the Aire and Calder canal at the head of the Humber estuary. When Chappell was a boy, sailing ships, large and small, came there to deliver pit-props and timber and load coal. General cargoes were shipped to Continental ports and to London in the holds of Goole-owned steamers, while from the old Barge Dock Quay could be seen a confusion of masts and yards belonging to the schooners, billy-boys, ketches and keels. Full-riggers and barques came up the Humber laden with wheat or fustic, a wood originating in the West Indies and used for dyeing, and vegetable oil was imported from the Mediterranean. Over four hundred sailing vessels were registered at the port and fifty ship-owners lived at the inland port.

Chappell, the youngest of six children, grew up within sight of the masts and yards that rose above the dock buildings. His father, a joiner and later cabinet-maker by trade, encouraged him to take up a scholarship which secured him a good basic education. He had begun to draw ships from infancy and like many of his generation developed an interest in photography. Upon leaving school he was fortunate enough to be able to transform a hobby into a career and was apprenticed to a photographer, and tinting photographs led him into painting. Apart from a few formal art lessons he was self-taught.

By his late teens Chappell was augmenting his very modest income by contributing line drawings to local papers and his paintings of ships were attracting attention amongst the seafaring community of the little port. There were few in Goole who did not have some connection with ships and the sea — some owned shares in the ketches and schooners, others had relatives amongst the crews; an élite could claim connection with the masters of the newly-launched steamships. Sympathetic to his son's ambitions, Reuben's father contributed a small studio to further his career, and by his twentieth birthday the young Chappell was advertising in the local paper as a photographer and artist.

It is a little ironic that for one whose fame now rests upon his authentic portrayal of the last days of sail, Chappell's first major success was a portrait of the steamer *Wharfe* of the Goole Steam Shipping Co., in 1890. It was not shown

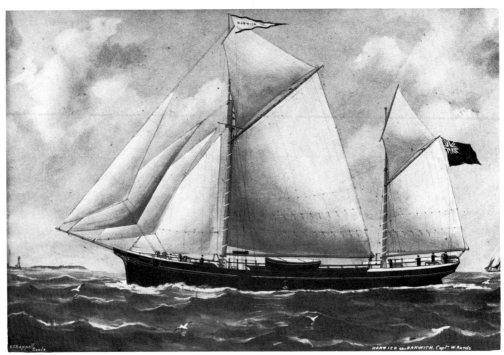

Reuben Chappell               *Gouache on paper*               *14 x 20 ins.*

'*Harwich* of Harwich Capt. W. Rands'. A fine example of Chappell's early work when he was still painting at Goole. The *Harwich* was an early example of her type, combining the hard chined, flat bottom and lee-boards of a barge with the full rig of a ketch. When first launched at Brightlingsea, Essex, in 1867, she carried a square topsail. Originally owned at Harwich she worked in the North East coal trade and was loading at Goole when her skipper commissioned this painting. She was later owned at Nottingham, Dorset.               *Jack Haste*

in a gallery, but with less dignity but more likelihood of ensuring further commissions, displayed in a furniture shop window so that it could be seen by seamen as they made their way to the Docks. The painting of the Goole ketch *Princess* illustrated here, dates from this early period in Chappell's career as a ship-portraitist. His principal source of commissions were the masters of the keels and sloops, the traditional sailing craft associated with the Humber and its network of waterways reaching far inland.

Despite his photographic training, Chappell did not employ the camera to assist him in his work. A precise and methodical draughtsman, he assembled his material from preparatory notes he made in a series of linen-covered sketch-books. I have examined some, dating from the years immediately preceding and following the First World War. They show carefully-drawn details of the bows of every individual vessel with any decoration it might carry, its stern and associated detail, and above them a spar-plan pencilled in with related proportions of the masts, yards, gaffs and booms indicated by numbers. Identifying code-flags are noted.

Occasionally there are notes of where the setting up of the rigging or the form of the vessel's rail differed from the conventional practice; that, for instance, the topgallant rail was painted white or that the bulwarks were dark green; that the main gaff peak haliyard was chain or the mizzen shrouds were set up with turnbuckles. It was, of course, accuracy in such points that endeared Chappell to his patrons who wanted, above all else, correctness of detail.

Throughout his life Reuben Chappell was dogged by indifferent health; it is probable that if it had not been for a bronchial weakness he would have gone to sea. It was upon medical advice that he forsook the raw wind and rain of the East Coast, and in 1904 he left Goole for the more salubrious climate of Cornwall and settled in Par. In those days Par was a small port, but a lively one, and Chappell knew it from the visit he had made aboard the Yorkshire billy-boy *Daisy*, a little ketch of 75 tons, to be a harbour frequented by small sailing ships and steamers, particularly the Danish schooners whose masters and crews had favoured his work at Goole. The china-clay quays of Fowey and Charlestown were not far distant and all attracted vessels whose owners, masters (often one and the same) and crews had a pride and personal interest in their little vessels which was often expressed by commissioning a ship-portrait. A wide variety of vessels — West Country ketches

*Reuben Chappell*                    *Oil on canvas*                    *21 x 35 ins.*

'*Britannia* of Harwich, Capt. Goodman'. Chappell's oils have in many cases suffered by the passage of time and this early oil shows another ketch-barge, this one without the counter stern of the earlier-built ones. Launched in 1893, the *Britannia* survived until lost off Yarmouth in 1929. *Author*

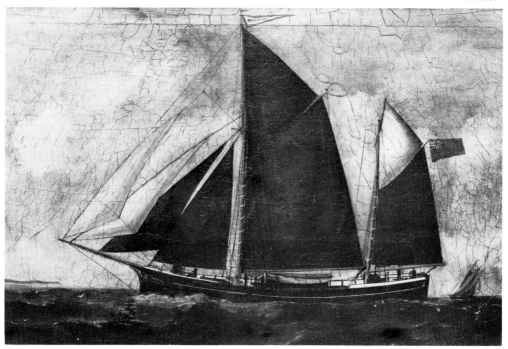

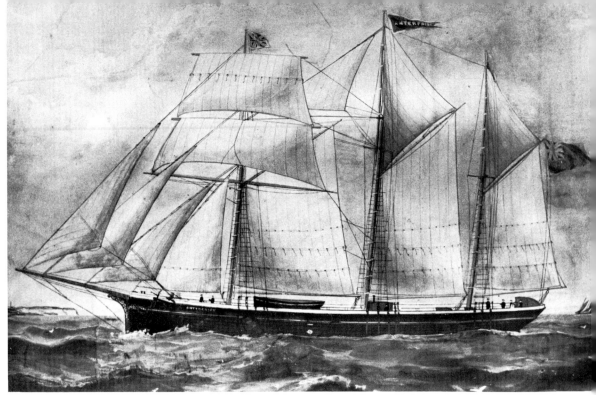

*Reuben Chappell*               *Water colour on paper*               *14 x 20 ins.*

'*Enterprise* of Yarmouth'. A barge-built three-masted topsail schooner, launched expressly for the coal trade, at Yarmouth in 1891. She had lee-boards, which may be made out just abaft the fore-mast. Owned by Bessey and Palmer, she later had an engine installed.     *Robert Malster*

and schooners, Dutch galliots and Danish galleases, East Anglian ketch barges and South Coast brigantines lay alongside the quays, their rigging turned white with the clay they loaded. After a brief period, during which he tested the market, he sent for his family and they settled there, to depend upon the industry of his brush for the rest of his life. From the men of the ships who used the clay ports of the extreme South West Peninsula Chappell solicited commissions for paintings. As ships docked, the familiar figure visited the quays and jetties, self-contained and a little incongruous amongst the seamen and dockers, clad winter and summer in a Norfolk suit, a roll of paintings under his arm to show examples of his skill to potential patrons. To maintain a family in this way, for Chappell now had three children, meant a life of conscientious labour at his drawing board and easel. Mr Ward-Jackson, calculating the numbers from the painter's carefully-kept diaries, shows that even when war-time regulations restricted his work, in the year 1916 he produced 395 ship-portraits, in 1917 only slightly fewer, and when peace came the year 1919 saw an incredible 483 paintings sold. No doubt the temporary rise in freight rates due to war-time conditions at sea followed by the short-lived post-war boom, is reflected in the increased sales as owners and seamen found a bigger

margin for indulging their pride in their little ships. In 1920 Chappell recorded the sale of 509.

It has been estimated that throughout his working life Chappell produced more than twelve thousand ship-portraits; some were of the same vessel, sometimes recorded after a period of years for a different master; some were the traditional pair of "fine and foul weather" paintings, one showing the ship with all sail set and the other with the canvas snugged down to weather out a storm. But to have produced such an astonishing total within a limited working life is an achievement without parallel in the field. Customers would sometimes stipulate the setting of the subject, such as "Off the Eddystone" or "Entering Fowey Haven"; alternatively Chappell would emphasise the horizon with a smack or steamship and punctuate it with a familiar headland or lighthouse in the tradition of ship-portraitists.

Despite such an enormous output, his professional standards were high. His clients were rarely indulgent of any technical solecism and demanded a high degree of fidelity; they were fully prepared to refuse to accept a painting which did not reach their high standards, for exactness was valued before everything, and this ensures that Chappell's paintings, made throughout his life, are not only a decorative, but also a dependable, record of the past.

Reuben Chappell rarely dated his work, but merely signed it "R. Chappell Goole" and continued to do so for some years after he had taken up residence in Cornwall. Later he signed his paintings "R. Chappell", occasionally "R.C.", and rarely "R.C.G.". In the opposite corner to his signature in white capitals the name of the vessel, its port of registration, and usually the master's name were added.

His earlier work in Goole had been largely in oils on canvas, usually 21" x 35". Unfortunately the economic limits within which Chappell worked forced him to use inferior materials and many of the early oils have shown signs of deterioration. It was only in his most prolific period that Chappell made water colours his main medium of expression. The owners and captains of the robust square-sailed Humber keels and sloops, were amongst the first of his customers. He did not shrink from attempting to capture the essence of tide-racked waters of the Humber estuary, churned to a yellow brown, in these paintings, confirming the location of the scene with the two points of land best known to the seamen of the Humber, Whitton Ness and Spurn Point. Despite commissions from steamboat men, which must have encouraged him to believe that one day he might enjoy the patronage of the relatively well-off, these and such paintings in oil of the *Princess* of Goole and *Britannia* of Harwich are relatively rare. Materials, canvas, stretchers and oil paint were far from cheap and Chappell's charge at this time, the turn of the century, of thirty shillings for a ship-portrait in oils, left him little profitable margin, while it effectively placed the acquisition of a picture beyond the reach of many potential buyers amongst the seafaring community he met. Perhaps because

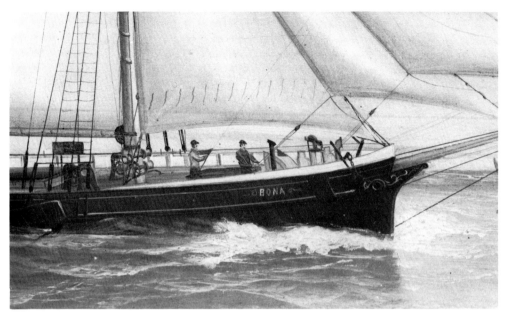

*John Henry Mohrmann*          *Oil on canvas (detail)*          *28 x 40 ins.*

Ketch-barge *Bona*. The skill with which Mohrmann could render figures and seas without removing his work from the vernacular into the academic is well shown here. It says much for the efficiency of these craft that their comparatively well-off skippers could afford the price that Mohrmann commanded for his pictures.          *M. Garnham*

of his responsibilities being less pressing and his youthful enthusiasm not yet blunted by repetition, his output at this period is probably his best.

Chappell turned to using gouache as a medium for a short period in an effort to explore the possibility of producing a picture as appealing as one in oils, but more economical in materials. Perhaps he was consciously imitating the Mediterranean ship-painters whose work he probably had the opportunity to study in the homes of the schooner-owners of Goole and Knottingley. An example of his work in this medium is a painting of the ketch-barge *Harwich* reproduced here. He did not pursue his experiments with gouache, and no doubt through sheer pressure to paint an inexpensive and rapidly produced picture, for the market for oil paintings was inevitably limited, he turned to transparent water-colour. His water-colours are heightened with body-colour to give precision to the details and an intensity of tone to signal flags and varnished spars.

The water-colours, which represent the bulk of his work, usually 14″ x 20″, though occasionally larger, he sold for a modest five shillings each, rising by 1915 to seven shillings and finally in 1930, by which time his output was small, to fifteen shillings. But these prices must be seen in perspective. In 1900 a skipper's wage was between five and six pounds a month although this might well be augmented by virtue of the fact that he held shares in his vessel. Chappell's

paintings were usually framed by the purchaser at his home port and in the heavy, ornate gilt moulding popular at the time. Unfortunately the simple sycamore or bird's eye maple of Victorian days had, by then, passed out of fashion.

Reuben Chappell suffered a minor stroke in 1925 which, alas, left him with his eyesight impaired. But he still continued painting, portraying American steamers and Scandinavian schooners, sending pictures as far afield as Finland and gradually, to greater extent, finding subject matter in bigger, powered vessels. After 1930 he painted but little and on 20th July, 1940 he died as a result of bronchial pneumonia, a few days after his seventieth birthday. In the same year the last West Country trading schooner was laid up in Par Harbour, never to sail again under the British flag.

If Reuben Chappell had a competitor in the sheer volume of the work he produced, it was the American, John Henry Mohrmann. Two more disparate characters could scarcely be imagined. Mohrmann was born in San Francisco in 1857 of German parents and went to sea as a cabin boy at the age of thirteen, rounding Cape Horn before his fourteenth birthday. As a seaman he served before

*John Henry Mohrmann*                *Oil on canvas*                *28 x 40 ins.*

'Four masted barque *Eilbek*'. Painted when she had passed under the German flag and was owned by Knohr and Buchards, the *Eilbek* began life as the British *Moreton*, built at Port Glasgow, 1892, during the last phase of deep-water sailing ship construction. It is interesting to note that by this date a steamer-type bridge has been adopted, just abaft the mizzen mast, to give a better position for command than the traditional poop where the helmsman stands.

*Simon Carter Gallery*

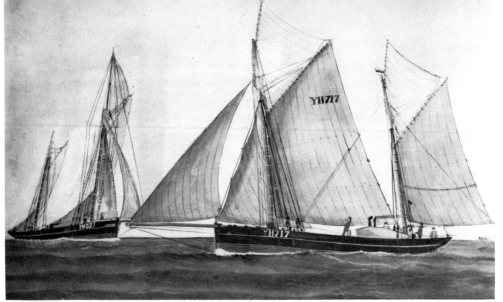

*Tom Swan*  *Water colour and ink line on paper*  *19 x 24 ins.*

'Convertor' smack *Sleet*, YH 717. Smacks such as this, hailing from Yarmouth, where the *Sleet* was built in 1877, drifted for herring and mackerel. They had been built as luggers and converted to the handier gaff rig, hence their name. They were built with carvel planked topsides and below were clinker planked, as may be seen in the painting.

*Norfolk Museums Service, Great Yarmouth Museums*

the mast for fourteen years, lacking any opportunity to acquire the most rudimentary training in art. His opportunities to exploit a natural gift were limited to painting cigar-boxes for his shipmates.

At a later stage of a roving life he is said to have secured some formal instruction in painting as a student at Antwerp Academy. This one can well believe for his capacity to realise figures in movement with paint is high, always a stumbling block to the untrained while the sense of spatiality he achieves in his settings is extremely competent. He certainly assisted an Italian friend to paint murals in a church at Kassel in Germany and worked at one time as an assistant to a picture restorer in England. While his earliest ship-portraits date from 1881 it was not until 1890, when after a restless life at sea he settled in Antwerp, that he began to produce ship-portraits in earnest and as a primary source of income. One of the busiest ports of Europe, Antwerp saw every type of vessel berth at its quays and all were acceptable material for Mohrmann's brush. His range was wide both in subject and setting and he accepted commissions from the skippers of British ketch-barges, which loaded a modest 150 tons of Belgium tiles, as well as from the captains of the big steamers and windjammers of twenty times their tonnage.

Mohrmann signed his paintings "J.H. Mohrmann" usually in red, and his paintings which have survived are all oils on canvas produced on a large scale, 23½" x 39½". His paintings of British ships, sail and steam, often included a

surprisingly sensitively painted background of Beachy Head and in the foreground a sailing pilot cutter. In addition to steamers, Mohrmann produced paintings of windjammers, and his work is preserved in collections on both sides of the Atlantic. In 1908 he was paid the equivalent of five pounds for a ship-portrait and this says much for the high regard in which his patrons held his skill and their commands for he was rarely without employment. In 1913 Mohrmann crossed the Atlantic again to settle in Canada, where he died three years later.

It was not only the merchantmen that were recorded by ship-portraitists, artists like Mohrmann and Chappell. Although individual fishing-vessels do not figure at all in the eighteenth century and only very occasionally in the first half of the nineteenth, a rapid change was to take place after the eighteen fifties. The second half of the nineteenth century saw a vast and colourful congregation of fishing vessels brought together in the ports along the East Coast, adjacent to the rich fishing-grounds centred on the Dogger Bank. Before this, for centuries, fleets of drifters had followed the herring shoals down the length of the North Sea and these continued to grow in size and strength. By the 1850s the railways were available to distribute fish rapidly, tolerably fresh, all over Britain and the railway companies assisted in developing dock facilities for the trawlers. Taken together as a group the trawlers, drifters and long-liners perpetuated, until well into the twentieth century, long after mechanical propulsion had begun to revolutionise

*George V. Burwood*                    *Oil on canvas*                    *28 x 32 ins.*

'Rescue of the survivors of the *Elbe* by the smack *Wildflower*'. In 1895 the German passenger liner sank in collision with the loss of 334 lives and the only survivors were picked up by the Lowestoft smack. Fishing vessels were frequently involved in rescues in the North Sea although few earned the rewards bestowed upon the crew of the *Wildflower*.

*Lowestoft Maritime Museum*

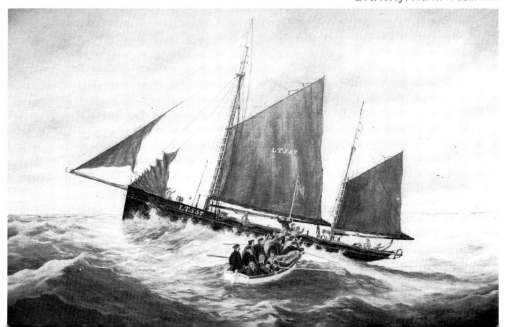

the industry, the conditions which brought commissions to the ship-painters. The fishing vessels continued to be owned by individuals, by families or small companies with a strong, local family basis. They and their crews were almost all members of a closely integrated community and the vessels were often locally owned, built and maintained.

Although steam power was introduced from the eighteen eighties onwards it had made little change to the basic pattern of manning and ownership and consequently ship-portraits were still in demand. At first steam was used to hurry the delivery of the catch to market and fish-carriers collected fish from the trawlers, still dependent upon sail, far out on the fishing-grounds. There was an interim period, prior to the general adoption of steam in the fishing industry, when under-employed steam tugs were adapted to be employed as trawlers. But although sail survived in the West Country and at Lowestoft, on the East Coast, longer than elsewhere and in the drifters everywhere, by the nineteen twenties powered craft were almost universal. The introduction made little difference to the demand for ship-portraits; steam or sail, trawlers or drifters, ship-portraits depicting every type and build survive, in large numbers, and were produced in profusion until relatively recently, when finally the camera superseded the brush.

*P. Gregory*                    *Oil on board*                    *22 x 26 ins.*

'Drifter *Renown* on passage.' Lowestoft drifters went far afield after Christmas to take part in the West Country mackerel fishery and the artist underlined the occasion by including the Eddystone light in his picture. The huge topsails were known as "jigger topsails" to the fishermen at Lowestoft.                    *Norfolk Museums Service, Great Yarmouth Museums*

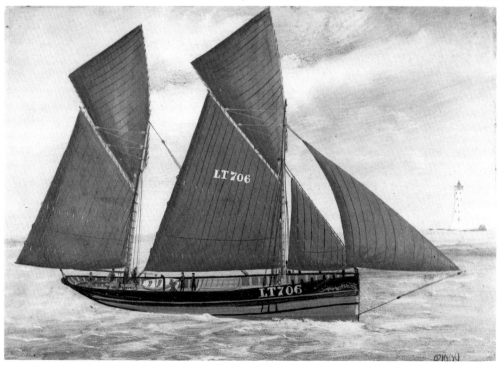

One of the most prolific of the painters who found employment amongst the fishing fleet and whose work had been widely distributed was George Race. His output over nearly half a century approaches that of Reuben Chappell and the period in which he was at work covers roughly the same limits as those of the Goole-born painter. Race began his working life in a little wooden cottage over-looking the Humber, on the sea-shore at Cleethorpes; so close indeed that it was washed away by high tides in 1914. By the time he was eighteen years of age, about 1890, although he had no formal art training he was supporting his mother and father. His father delivered the finished oil-paintings to the Grimsby fish-docks and secured fresh commissions from the skippers, although the proceeds of sales all too often went to augment the profits of Lincolnshire brewers before he reached home. At this time there were no less than eight hundred sailing and thirty-five steam trawlers working from Grimsby. The autumn herring season increased the numbers and brought large fleets of sailing drifters from Scottish fishing ports; great lug-rigged craft up to eighty feet in length. Paintings of them by Race still hang in fishermen's grey-stone cottages from Lerwick to Eyemouth and their crews kept him fully occupied with commissions when they were working from English ports. But nevertheless during the lull between the herring seasons Race found it necessary to seek employment as a sign and scenic artist in Cleethorpes and Grimsby. However, as long as the fishing season lasted there was employment for his brush and, like the drifters following the herring shoals south-ward, Race moved on with his family in the late autumn to Lowestoft and Yarmouth. In at least one respect fortune favoured Race. The turn of the century saw a radical change in the composition of the Grimsby fishing fleet. The facilities at Grimsby were ideal for steam, and within a very few years some five hundred new steam trawlers had all but replaced the wooden sailing smacks, providing potential orders for the artist. George Race died in 1957, but his son William born in 1901 has fortunately left a unique and sobering account of the life of a pier-head artist. "He would sit up at night," he records of his father, "painting one of his pictures to get it ready for a boat leaving next day, he would dry his pictures in front of the fire, to hurry drying; if he missed the crew paying off we went hungry. His pictures ranged from two and sixpence and if he got a good order for one, seven and sixpence to ten shillings, we didn't eat bread and dripping that day we managed to get some bread and jam. I first went with him to Lowestoft in 1910 (William was then nine years old) to help him. In those days he was painting pictures in lifebuoy frames for which he got two and sixpence each ..... We lived with an old blind man ..... we worked in his little workshop at the rear of the house, all my father had was a paraffin lamp to work by and a blanket wrapped round his legs to keep warm. Many a time he worked all night to have pictures ready for the morning. I don't know how the devil we lived."

After war service, beginning in 1914, George Race returned again to painting

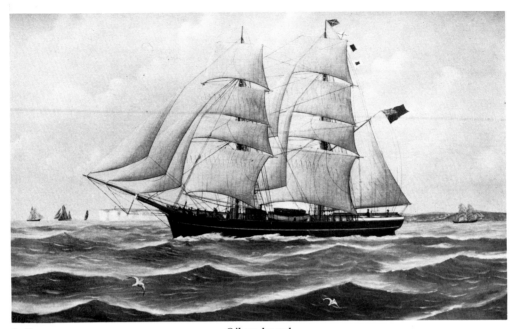

*J. Fannen*                                                *Oil on board*

'Brig *Corcyra* 1889'. Whilst once the North East coast had mustered fleets of brigs numbering hundreds, by the time the painting of the *Corcyra* was made they had dwindled to a few dozen. She was launched in 1850 at Sunderland, 201 tons. The bentink-boom beneath the fore-sail was a feature of the rigging of these vessels and assisted in going-about when short-handed. Aft of the fore-mast is the galley, with the stove chimney smoking and two boats are carried on the main-hatch.                                                *Simon Carter Gallery*

the East Coast fishing fleet, the husky distant-water trawlers working from Grimsby and, when the time came round, following the drifters, now all steam powered, down to Lowestoft. William Race continues his account; his father was now lodging with a smackman's family and using an old store and sail loft at Lowestoft as a studio. "I used to go down on the docks at Grimsby and Lowestoft to get orders for him and many a time he painted boats without seeing them. I used to get the boat's number and colours, funnel and casing, lifeboat and all particulars. He would look at the list and say *Herring Gull*, she's one of L.G.S.'s, built by Chambers Yard. He knew the style of each firm's boats. There was Chambers, Colbys, Richards, all wooden hulls, also Crabtrees at Yarmouth, iron built. Sometimes he used to stand on the dock-side and sketch them free-hand, never used a ruler."

George Race continued to paint ship-portraits until well into the nineteen thirties — one of the last pier-head artists — by which time there was little enough profit to spare on ships, let alone on ship-portraits. Within the last few years the paintings of George Race, like the work of so many of his contemporaries, have appreciated in price enormously; it is sad to recall his lack of worldly success during a lifetime of unremitting toil.

Race was not alone in recording the fishing fleet and he had a number of competitors working in the fishing ports. It was at Yarmouth that Tom Swan sought patronage from the fishing fraternity and his paintings have a naive appeal all of their own, for he owes no debt to an academic, or indeed any other style. Race's oil paintings are usually on a relatively small scale, precise and careful, but through no doubt over-production, in a low key. Swan worked with considerable invention and of all the pier head artists' paintings I have seen none seems to convey such an obvious sense of enjoyment in his work. Whales spout: the horizon is filled with ships and immaculately cut sails are spread aloft, his ships are toylike, but toys that float and work. He usually painted on paper, mounted on card, at least 19" x 24" in size, employing both body colour and transparent washes of water colour reinforced with a bold ink line. He worked at the period when steam was making its first inroads amongst the fleets of sailing drifters and smacks and he derived an added zest from depicting the novelty of Woodbine funnels and curling black smoke. Yet little is known of Tom Swan; his paintings are dated between approximately 1890 and 1914 and his capacity for depicting the technicalities of fishing and fishing ways, to say nothing of handling such demanding subjects as a jury rigged smack making port, seems to suggest that he had firsthand experience of life aboard the smacks. For the rest, his paintings are his memorial.

Amongst other pier-head painters who served the fishing fleet was P. Gregory, who combined ship-portraiture with sign painting. He worked in oils and on a large scale and displayed a considerable natural gift for handling the medium in a bold

*George Laidman*                 *Water colour on paper*             *5½ x 7 ins.*

'Billy-boy *Star of Hope*'. Painted in 1938, long after the *Star*, built in 1857 had finally set, Laidman who had served as mate, produced this typical miniature from memory. The broad red painted wale (painted blue as a sign of mourning when George's father died aboard) and clinker-built hull are typical of the billy-boys, as are the tall topmast and lee-boards.

*Kings Lynn Museum*

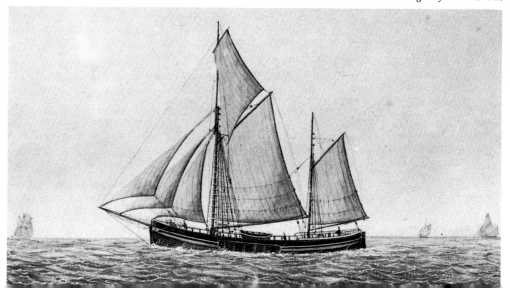

effective style. He usually signed his work with a "P.G." monogram. An unusual combination which linked the traditional method of recording a ship in paint with the technique of photography was employed at Yarmouth in the more sophisticated work of Mowle and Luck. Kenneth Luck painted oil portraits of the trawlers and drifters from the photographs produced by the camera of his partner; Mowle and Luck, Military and Civil Photographers of Gorleston, form a bridge between the old and the new, for after them, except for pictures intended for the Board-Room and the trade calendar, the photograph replaces the painting.

Luck's compositions have an imaginative touch and, whatever their inspiration, a sturdy appeal, while the availability of better quality yet inexpensive materials at this late period, assist in giving his productions an unusual brilliance of colour. Earlier ship-portraitists, working in oils, who painted creditably for the men and owners of the smacks and trawlers, although their pictures earned the painters reputations rather than livelihoods, were numerous. J.T. Boyne (fl.1900-10), W. Jenner of approximately the same decade and E.G. Tench (1880-1946) all worked with a pleasing vigour. Charles McKinley (1845-1910) was associated with the Ramsgate sailing trawlers. At the age of ten he was apprenticed to one of the Ramsgate smacksmen and eventually became a skipper himself. He usually worked in water colours. Work by many of these journey-men artists is to be seen to advantage in the Great Yarmouth Maritime Museum and at the nearby Lowestoft Maritime Museum. Surrounded by models of vessels of the same *genre* and the antique complexity of gear once used on the Leman Bank, the Wold or the Silver Pits, they have found an appropriate home.

During the last quarter of the nineteenth century the coal ports, both the traditional one of the North East and the newer harbours on the Western seaboard, were the scene of as many arrivals and departures of shipping as the fishing ports, but of a much greater total tonnage. In variety and scale the number of vessels leaving and arriving on each tide was without comparison. Grimy steamers leaving for Naval bunkering stations could be seen passing windjammers under tow bound for the Pacific, and the last stragglers of a once huge fleet of brigs, brigantines and ketches hoisting their grey canvas.

It is therefore not surprising that the coal ports supported many ship-portraitists; E. Wilkinson, John Hudson and J. Fannen were working at Sunderland, the paintings of the latter having an especially wide distribution. Fannen seems to have found a particularly loyal patronage amongst the skippers of the smaller wooden craft left in the coal trade "pumping coal up and sailing chalk ballast down". A semi-professional artist, he was a policeman who, no doubt, found painting an occupation well adapted to the unsocial hours and the inevitable isolation of his job.

At Stockton M. McLachlan became a recognised and well patronised ship-portraitist after beginning as a ships' painter in the dockyards. Like many of his contemporaries he used builders' drawings which enabled him to provide a painting of a vessel before the subject of the picture had left the launching ways. Nevertheless his settings are usually convincing enough and considerably livelier than some by those who employed this expediency to ensure the accuracy of technical detail. T.G. Purvis of Cardiff was another who earned commissions from captains and crews of vessels in the coal trade.

The little ketch-rigged billy-boys in the coal trade brought black diamonds from the Humber to the East Coast ports and amongst these was the *Star of Hope*. The *Star* was skipper-owned and like so many commanders of small coasters the captain bred his own crew; George Laidman of Lynn became successively seaman and mate of the *Star of Hope*, serving under his father and sailing between Hull and their home port of Kings Lynn with homely cargoes of coal and cattle-cake. When George's father died aboard the family ship as the result of an accident the son skippered her himself for a time and then went ashore; but he still kept one foot in the brown tide of the Ouse by enrolling as a Water Guard in the Customs and Excise Service. Like J. Fannen of Sunderland his days were split by duty and an official of H.M. Customs and Excise must inevitably limit his socialising in the interest of the Service and impartiality. George Laidman discovered a talent for painting ships and was kept fully occupied with orders from seamen whose vessels lay in Lynn Dock and the fishermen of the Wash. Although he painted a few pictures of conventional size he became the first and last marine miniaturist amongst the pier-headers.

His surviving work includes paintings of steam-ships, fishing and pilot boats and the last of the sailing-coasters, all meticulously worked on paper or board rarely larger than five by eight inches, but complete in every detail. In his later days (George was born in 1872 and died in 1954), he worked with no less than three or four pairs of *pince-nez* precariously balanced on his nose in order to place the last ratline and reef-point correctly in position with his tiny brush. It is pleasant to record that he did not let his official status prevent him from occasionally accepting a small box of cigars as an alternative to a cash settlement when delivering a painting to a seaman-patron although, of course, only upon his retirement.

# Across the North Sea

T HE continual and long established "Home Trade", which was the official
designation for the coming and going of shipping between British ports and
the coast from the Elbe to Brest, brought back to seamen's homes ship-portraits
from a dozen different continental harbours of Northern Europe. Each one
supported its own group of ship-portraitists with a distinctive style and pictorial
tradition. The short-sea trade and the commerce to the Baltic drew in an even
wider and more varied spectrum of shipping than the Mediterranean voyages. The
hulls of the ships trading regularly to the warmer seas of Southern Europe, unless
they were sheathed below the water-line in zinc, copper or yellow-metal, rapidly
succumbed to the insidious attacks of marine worm. This protection was expensive
to provide and maintain and it was only adopted by an élite of the smaller vessels.
Consequently the coasters and short-sea traders included in their numbers small
craft scarcely capable of an open sea voyage, centenarian tore-outs and vessels

*Anon.*           *Water colour with line on paper*

'Galliot *Sint Johannes of Trondhjem*, 1750'. A very early ship-portrait from Northern Europe,
it shows one of the Scandinavian carriers of the period with the typical galliot bow, stern and
immense decorated rudder-head. Despite the low profile of a more modern vessel, which must
have made for a weatherly ship, the driver on the mizzen-mast was still set from a lateen yard.
*Norsk Sisfartmuseum, Oslo*

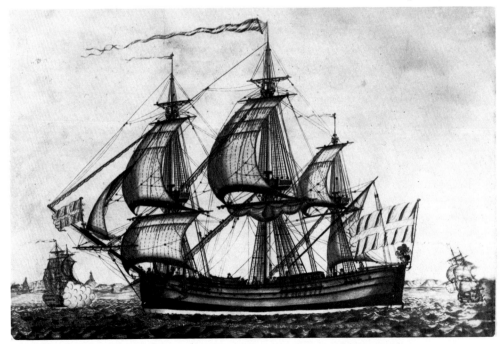

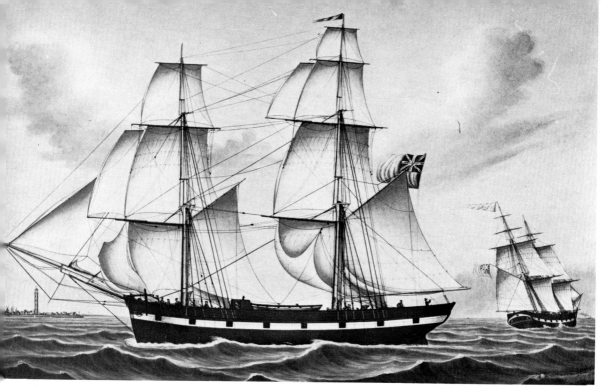

B. H. Hansen, Altona           *Water colour*           *18 x 28 ins.*

'*Tagus* of Sunderland, Joseph Woodruff Commander 1849'. Here seen clearing the Elbe, the *Tagus* was built in 1839 at Sunderland by John Watson, 269 t.g. Besides crossing the North Sea with coal and glass the little brig traded to America. Hansen included, whenever possible, another view of the same vessel on his canvas, stern on, with appropriately trimmed sails.

*Sunderland Museum, Tyne and Wear County*

whose style and rig was considered antique even by their sympathetic contemporaries. To us they are as interesting and characterful as their more expensively equipped sisters, although restricted to Northern waters. They were recorded in paintings just as the traders to Naples and Smyrna were, although the ship-painters who produced their portraits in Northern Europe were the inheritors of a different tradition.

The pier-head artists of Altona, (a port close by Hamburg) Antwerp, Copenhagen and many more, produced paintings which are, in many cases, the only pictorial evidence we have left to us of how the ships they depicted sailed and how details of their build, sails and rigging appeared. Only a proportion of these vessels survived long enough to be recorded by the camera, by which time they were cut-down, worn-out caricatures of their former glory.

Many of these paintings are unsigned by their creators. It is, however, possible sometimes to recognise certain individual styles of painting and identify as clearly as the signature of the painter the conventions he adopted. The views which are included in the background in a picture make recognition of an artist's home port

relatively simple and may provide a clue as to his identity. Some painters, however, anxious to gain a patron's approval, would include a coastline hundreds of sea miles from his own familiar shore, the details drawn from an illustrated book of sailing directions.

Perhaps because of the slower speed at which industrialisation had taken place and a resulting preservation of older ways and communities, many of the painters of Denmark, North Germany and the Low Countries were closer to a livelier, unsophisticated peasant tradition of visual expression than the British painters. The majority did not have the same background of a vigorous officially recognised academic marine art upon which to draw. Their paintings have a naivety about them which distinguishes them from many originating from British ports. It is certainly harder-edged, it tends to lack any tendency to free brush work and is even more uncompromisingly veracious than its British equivalent. The painters searched for pattern, no doubt unconsciously, rather than for a dramatic effect. The pleasant and useful convention, in defiance of actuality, of showing two views of the same vessel upon the same canvas survived longer amongst the ship-painters of Altona and Flemsburg than elsewhere.

Most popular of all backgrounds to appear on canvases was Kronborg Castle, which is frequently used in paintings by Jacob Petersen (fl. 1830-50). It is at the

*Jacob Petersen*          *Gouache on paper*                    *17¼ x 24 ins.*
Snow *Triton* of Sunderland c.1840. An earlier snow, identifiable by her absence of driver boom, built at Sunderland in 1824. She still carries a fore-royal which must have marked her out as a favoured vessel amongst the hundreds of North East Coast brigs and snows. Kronberg castle in the background of the painting was usually included in Petersen's pictures.
*Parker Gallery, London.*

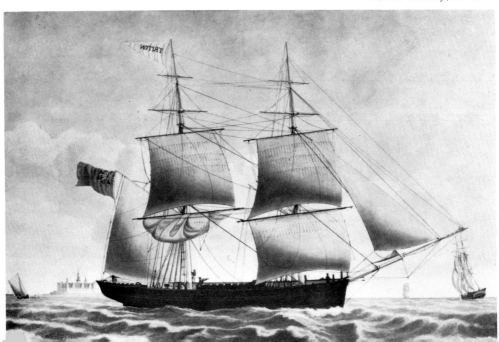

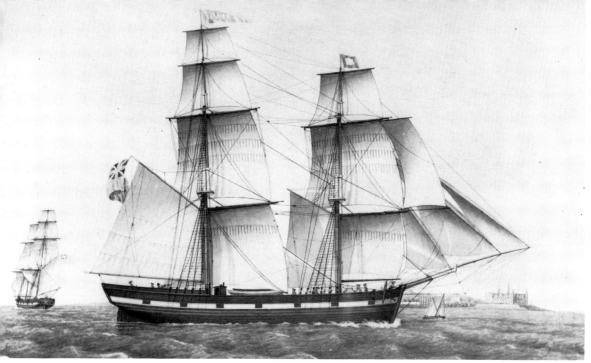

Jacob Petersen          *Gouache on paper*          *17 x 24 ins.*

'*Elvira* of Lowestoft, Captain J. Elven, 1860'. More typical of the vast output of Petersen, this painting of Sunderland-built brig of 1832 was made during her short ownership away from the coal ports. She was re-sold to Sunderland in 1863.      *Lowestoft Maritime Museum*

narrowest point of the Oresund, which, before the construction of the Kiel Canal, was the entrance to the Baltic. Through the Oresund (during the summer trading season) passed the collier-brigs and snows of the North East coal ports, returning with timber, tallow and flax. Petersen and D. H. Hansen produced many immensely painstaking portraits of these little ships. Other favourite background views included in pictures from this area were the old lighthouse on Cape Skagen and the Island of Bornholm.

Until appropriated by the Prussians in 1869, Schleswig-Holstein had a prosperous merchant-marine and portraits painted for the crews and owners were known as "Kapitan's bilder" (Captain's pictures). Altona, where once the Danish East India Company had its headquarters on the Elde estuary above the great port of Hamburg, was the home of a long and distinguished line of ship-painters. Their paintings were brought back to Britain aboard schooners and brigs to be proudly hung in sailors' homes all through the nineteenth century. However, their sheer size and their stilted style rather limited their pictorial appeal to later generations and they tended to be relegated to the attic or lumber-room as fashions changed, rather more rapidly than other paintings of the same *genre*. Many paintings deriving from Altona were by the Hansens; H. C. Hansen (fl. 1838-47), B. H.

Hansen (fl. 1827-56) and T. Hansen, working at approximately the same date, who were no doubt related. They must not be confused with the D. H. Hansen of Gavle in Sweden. Although the founding of the port of Bremenhaven in 1827 and the consequent increase of shipping on the Weser resulted in the port of Bremen being able to support its own group of ship-portraitists, paintings from this area are much less frequently met with in Britain. This port looked to Transatlantic and South American trade and the work of its ships is reflected in the predominance of portraits of ocean-traders and liners. The work of Carl Fedeler, who painted sail, but is chiefly remembered for his portraits of the North German Lloyd steamers was carried out there, while Carl Harman and Ottmann Jaburg were also prominent.

Scandinavian ports each had at least one painter. Andreas Lind painted at Drontheim until 1860 and then moved to London. There he followed the tradition of the pier-head artist, sketching vessels as they towed up the Thames and then producing a painting from his drawings, as a speculation. He would then take it on board the ship as it lay discharging in the docks, hoping for a sale. Painstaking ship-portraits by members of the Tudgay family are also associated with the Thames and especially Limehouse during the mid-nineteenth century. F. Tudgay (1841-1921) is perhaps the most talented; his luminous skies are particularly well

*H. Loos, Antwerp*  *Oil on canvas*  *21 x 27 ins.*

Brig *Viking*. Painted with a distant view of nineteenth century Flushing, the portrait of the *Viking* well represents the style of H. Loos. A vessel designed with a view to speed and good looks, the *Viking* was launched at Aberdeen by Burns in 1862, owned in 1866 at Wivenhoe, Essex, and broken up in 1878.  *Nottage Institute*

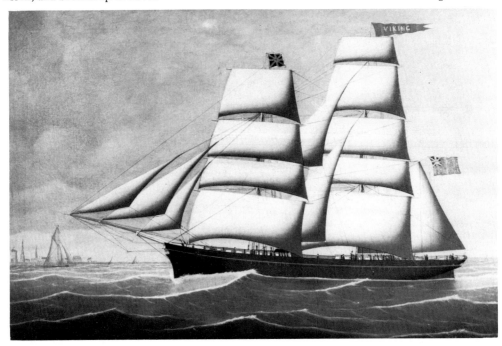

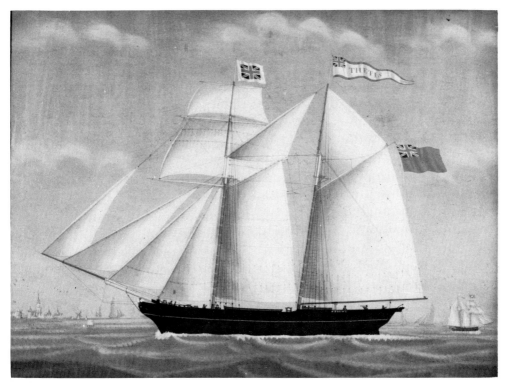

*Petrus Weyts, Antwerp*          *Oil on canvas*          *21¼ x 27½ ins.*

'Schooner *Thetis* off Flushing, 1844'. Although best known for his glass-paintings P. Weyts produced a number of oils very similar in style. The artist might be accused of exaggerating the proportions of the masts, but they are confirmed by surviving sail-plans, and an ample spread of canvas was necessary to drive the deep, heavy hulls of the time. Details of the rigging of the *Thetis* which are of interest include the diagonal line of reefing eyes across the mainsail and the gaff-foresail designed to brail against the mast.

*Kingston upon Hull City Council, Ferens Art Gallery*

realised and his portrait of the *Cutty Sark*, now appropriately exhibited in the clipper-ship herself at Greenwich, is especially fine. His meticulous attention to detail assisted in the reconstruction of the rigging of the ship when she was re-born in 1957. But it must be admitted that his 'seas', and those of the other members of the family, indicate a limited talent in that direction. Other paintings are signed J. F. Tudgay and J. C. L. Tudgay, indicating a collaboration between members of the family.

One of the last of the pier-head painters of London was C. Kensington who produced pictures of the surviving windjammers and powered vessels; he worked on until the nineteen twenties.

Antonio Jacobsen, born in Copenhagen in 1850, benefited from an academic art training and emigrated to America in 1871 where he painted in New York. Although his working life covered the heyday of the Transatlantic passenger

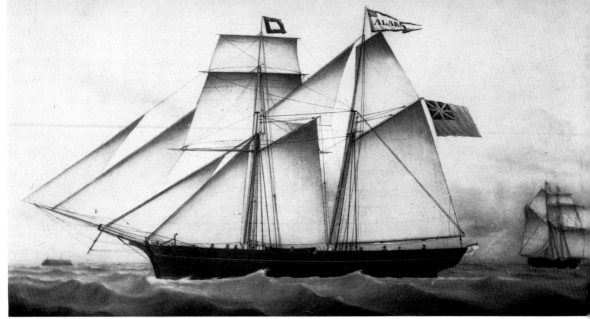

B. H. Hansen Altona          *Oil on canvas*          *17½ x 21 ins.*

'*Alarm* of Ipswich' 1856, Edward Johnson Commander. By the time the *Alarm* was launched in 1855, by Wm. Bayley at Ipswich, the brig was giving way to the schooner rig as the one most popular for small vessels, particularly for the Home Trade. The shallow draught of the *Alarm* made her particularly suitable for the East Coast. Her fine spread of square canvas may be judged from the stern view included in the composition.      *Ipswich Borough Council*

steamer and the emigrant trade, Jacobsen painted some sailing vessels and he seems at his happiest when portraying a sail-carrying liner of the eighties. His output was extensive and occasionally his style, particularly when seen on a large-scale painting, borders on the garish, but his roots in a vigorous folk-art are clear and he managed to avoid vulgarity; the only evidence of the debt he owes to his training in Copenhagen Academy is in his deft handling of cast shadows. For the rest it is saw-like seas, hard-edged colour and little sense of space. Unlike many of his contemporaries in the same field, Jacobsen found considerable financial reward in his chosen work. Examples of his pictures, particularly those of the Atlantic greyhounds of the nineties and nineteen hundreds, have been dispersed all over the world. He died in New York in 1921.

Not surprisingly, Holland and Belgium provided numerous artists to cater for all degrees of visiting seamen with varying depths of pocket who sought paintings of their ships. The work of Petrus Cornelius Weyts, or perhaps it is safer to say, productions emanating from his studio, are frequently met with in Britain. He was born in 1799 at Gistel, close to Ostend. His earliest known work is dated 1824 and he is said to have owed a considerable debt to established Ostend painters, although he would seem to be drawing at least as deeply in his ship portraiture from a naive long-existing folk tradition. Ostend, not then the packet and large scale fishing-port it is today, provided Weyts with only limited opportunities to

find patronage and the nearby rapidly expanding port of Antwerp, only a few miles distant, beckoned him. He moved there in 1838 and any paintings by him which have found their way to Britain almost certainly date from that year. But the fame of Petrus Weyts derives from the fact that he was an exponent of glass painting, and many of his ship-portraits were produced by this attractive technique. They are, perhaps, the most sought-after of all ship-portraits, and although examples by British painters, or perhaps they were in fact not Britons but Belgians resident in Britain, are not unknown, Antwerp, Ostend and Dunkirk produced nearly all the experts in this field. At Antwerp Petrus Weyts and his family almost monopolised production.

The difficult technique of glass-painting probably originated in Silesia, the centre of European glass-manufacture in pre-industrial times. It only spread outwards to reach the North Western coast and southwards to Italy at the end of the eighteenth century, carried by itinerant craftsmen.

The practice of glass-painting embraces many variations of technique and occasionally the use of gold and silver foil; however, the majority of ship pictures in this medium are straightforward in their manufacture although a carefully systematic approach and a sure touch were required to produce a finished article which would satisfy the purchaser. The first stage was for the artist to produce a drawing in pencil, complete in detail, of the vessel he was to depict, remembering that the viewer would be seeing a reversed image of the completed work. All

*John Henry Mohrmann, Antwerp*  *Oil on canvas*  *23½ x 39½ ins.*

'*Joshua Nicolson,* discharging pilot'. Mohrmann's handling of the difficult problems of perspective involved in the inclusion of the Cowes pilot-cutter indicates his professional training. The *Joshua Nicholson* was a Tyneside-built and owned iron steamer, launched in 1880.

*W. Lapthorne*

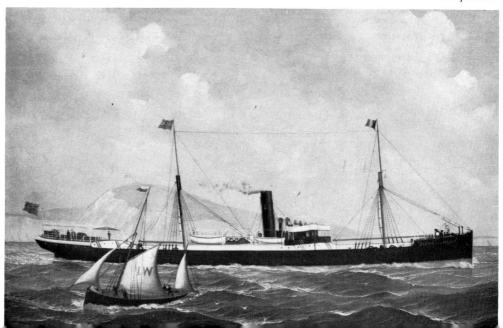

scenery would be drawn on the opposite side of the vessel and similarly lettering would be a mirror image of the intended finished effect. Small wonder that Petrus Weyts, when making his painting on canvas of the schooner *Thetis*, reproduced here, inadvertently reversed the vessel's name painted on the quarter-boards.

The preliminary pencil draft was then placed under the glass and the surface of the glass coated with gum or varnish to assist the paint to 'take'. Then the artist proceeded, working carefully at those parts which would eventually be covered, such as the vessel's bow-wave and wake. Rigging, channels for the rigging, seams in the hull's planking, the outline of the topgallant rail, the shadow under the quarters, were indicated in black with a 'pencil' brush. Decoration on the stem, bow and stern had also to be placed accurately at this stage. This was followed by the outlines of the sails, their seams and cordage on the fore side, after which the shadows and the whole sail followed successively. Only when these were completed could the spars, masts and rigging be superimposed, the order depending on whether the windward or leeward side of the ship was drawn. Finally when all the paint had dried the sea and sky were painted in, to cover the whole glass, although as in the portrait by the Dunkirk exponent of glass-painting, Alexander Lamaetiniere, illustrated here, a further refinement might be introduced. To achieve a three-dimensional effect to the picture a background, with a harbour and shipping, was painted in the traditional style upon a board or on a second piece of glass. This was mounted in the frame, some little distance behind the ship-portrait proper. On a glass-painting it is usual to find a title and the artist's name at the bottom of the painting, together with the painter's signature.

The ship-portraitists who produced glass-paintings used ordinary oil-paint, in which case each stage in the lengthy process had to be allowed to dry thoroughly before the next was embarked upon. To hurry the production of a picture, oil-paint was mixed with varnish and occasionally gouache and lacquer were employed. But whichever medium was used any small detail omitted in the earlier stages could never be added later. With this limitation it is hardly surprising that the artists rarely essayed anything but the straight-forward profile view of a vessel. Despite this, the combination of ingenuity and painstaking craftsmanship in a glass-painting made an instantaneous appeal to the nineteenth century seamen. Unfortunately the fragility of the material has increased their rarity.

With such a complex technique to learn it is understandable that the production of this type of ship-portraiture was limited to a small and exclusive band of painters. Beside Lamaetiniere at Dunkirk, an artist known only by the initials "PN" worked at Ostend. The complexity of the technique perhaps also accounts for it being almost a monopoly of the Weyts family. Petrus was assisted by his son Carolus and his brother Ignatius (1814-67) while another son, born after the family moved to Antwerp, was also apprenticed to the trade. The processess of the technique lent themselves to a division of labour and many Antwerp glass-paintings

signed by Petrus are possibly the combined efforts of the Weyts family. As well as glass-paintings, oil-paintings are to be found with Petrus Weyts' signature on them.

Other ship-portraitists, working in a conventional technique at the same time as the Weyts family at Antwerp were John and Henry Loos. Their work is rather hard and stiff, but very competent and like Weyts' paintings usually includes a view of Flushing — they are signed "J. Loos Anvers". But the Antwerp artist whose work has a panache and originality all its own is that of A. de Clerk (fl. 1870-1910). His patronage was drawn almost exclusively from the skippers of the schooners and ketches of the last days of sail and his paintings are widely distributed among British ports. He used a bold water colour and gouache technique simply and effectively, with little attempt at modelling. Yet he had an undoubted capacity to capture the individual character of a vessel and usually produced a "fine and foul weather" pair for his customers. When mounted and framed in Victorian gilt they made a truly imposing embellishment to a seaman's modest cottage. In Antwerp he is believed to be a "Sunday-painter", a semi-professional, but of such skill that he earned for himself the title, somewhat inappropriately, of the "Rembrandt of Antwerp". However, his deft skill would seem to indicate much more than an amateur's capacity for realising his aims and he has none of the amateur's plodding ambition to reproduce reality in its fullest detail. Was he influenced by the poster-art of the period, then at such a high level? His stylised representations of Flushing pilot-schooners and galleys, lightships and lighthouses in the background of his paintings are all equally individual in their realisation.

*Anon.*                    *Oil paint on glass*                    *21 x 30 ins.*

'*Princess Alice* disaster'. The heavy loss of life sustained when the Thames excursion steamer *Princess Alice* was in collision with a collier off Woolwich in 1878 both shocked and fascinated Victorian England, filling the press for weeks. From internal evidence we may assume this picture was produced by a continental glass-painter but under what circumstance remains a mystery.                                                              *Jack Haste*

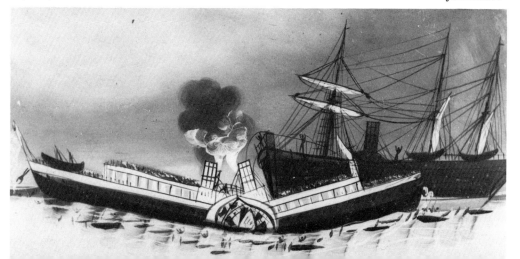

# Origins of Style

THE influence of an academic style of painting with a vision, aims and scale enjoyed by those of an educated taste ultimately shaped the style and conventions adopted by most British ship-portraitists, who appealed to a very different patronage. The influences only gradually and imperfectly percolated down to modify the sailors' artists and it must be emphasised that some painters remained firmly unaware of them, their efforts moulded by other influences from a deeper-rooted source. Ship-portraitists, working in the smaller ports particularly, could rarely have seen the originals which affected their modest work; the channel of communication was by way of the prints, principally lithographs, which were made from the paintings produced by the aristocrats of their profession.

*T. G. Dutton*       *Lithograph published Wm. Foster, London*       *12 x 18 ins.*

'The *Owen Glendower*, East Indiaman 1,000 tons. A fine example of Dutton's work on the stone and produced from his own water colour. The *Owen Glendower* was built at Blackwall in 1839 by Messrs. Green & Money Wigram, for their own use. She and three of her contemporaries were launched with auxiliary steam engines and paddles, but despite some early success these were found to have disadvantages and were removed. The *Owen Glendower's* normal run was from London to Calcutta, but in the early 'fifties she was diverted to the booming Australian trade.       *Author*

*Anon. Naples*        *Gouache on paper*        *16 x 23 ins.*

'*Wilshere* of Great Yarmouth'. Built at Fellows shipyard at Great Yarmouth in 1837 and named after the town's M.P., she was only 66 ft. in length, of 105 tons and schooner rigged for coastal trading. Her hull was subsequently sheathed in yellow metal and re-rigged as a brigantine in 1844, as her portrait shows, and she then traded to the Mediterranean, sailing outward from Liverpool with general cargo and racing home with oranges, lemons and other fruit in season. Returning to less spectacular voyaging in 1851 she reverted to a schooner rig. Lloyds Register lists her for the last time in 1865-6 and adds in the margin the word "wrecked".

*John F. C. Mills.*

*Richard Nibbs*        *Water colour on paper*        *9 x 15 ins.*

Brig *John* of Wells. A rare ship-portrait by Nibbs, painted when he was a young man. The *John* was built at Wells in 1811 and is typical of the small trading vessels of the period, owned by the brothers Martin of Kings Lynn and skippered by one of them, the painting was commissioned by the owners.

*J. Martin*

Topsail schooner *Emily*. The masterly use of transparent water-colour without resort to body-colour, a technique in which British painters excelled, makes this an outstanding portrait of a small trading schooner. Such paintings were an inspiration to many lesser portraitists in the same field.

The *Emily* was built in 1827 at Ipswich and like many of her kind lengthened later, in 1848. She was still owned at the port in 1868 and trading coastwise. On her foremast she flies the Mutual Insurance Society pennant.    *Norfolk Museums Service, Great Yarmouth Museums*

These were first made available by tinted etchings which date from the early seventeenth century. But it was the introduction of aquatints in 1775, and to an even greater extent, the widespread use of lithography after 1820, that enabled printmakers to give a wide distribution to the work of artists. Naval engagements were at first most popular, but by the nineteenth century prints illustrating merchantmen were finding a broad appeal. These were distributed through print-shops on a wide scale both in monochrome and colour. William John Huggins (1781-1845), marine painter to George IV and William IV, no less, had many of his paintings aquatinted and his hand-tinted engravings secured an eager acceptance by the public and connoisseur.

The work of William John Huggins, which found a wide market when beautifully aquatinted by E. Duncan and C. Rosenburg, has been described as

"careful but uninspired", yet he painted with a lightness of touch, despite the large scale of many of his canvases. He passed on to his numerous emulators an approach to his subject matter which was based upon an eighteenth century tradition, while his practical experience afloat ensured an authenticity to the manner in which he portrayed technical detail relating to ships and the sea. This knowledge is understandable for he had served as a seaman before the mast, voyaging to the China Seas before settling in London. Living conveniently close to the East India Office, he found patronage there amongst the Directors. Earning their approval, he found employment in portraying John Company's stately vessels with measured vigour in an appropriately descriptive style. Another ship-portraitist and a rather more pedestrian craftsman than Huggins was Thomas Whitcombe (1760-1824), who although he produced large-scale battle pieces also painted some merchantmen and prior to the time of Huggins' success in the field had his work distributed through the print-shops. Approximately at the same period others whose paintings were reproduced in engravings and aquatints were W. A. Knell (c. 1800-75), an early dabbler in the muddy pool of historical reconstructions, and Robert Dodd. But the true successor to Huggins may be said to be Thomas Goldsworth Dutton (1810-91) who produced lithographs of the highest quality which were published by himself in London and by Ackerman and W. Foster. Dutton's care, skill and infinite variety rapidly earned him an enviable reputation, although only a limited financial return, and he was commissioned to portray the finest flower of the Victorian merchant marine. East and West Indiamen, tea clippers, packet ships and emigrant ships were all recorded with a versatile and imaginative style. He was responsible for what is possibly the most frequently reproduced of any marine print, or indeed marine painting, 'The Great China Tea Race of 1866', showing the clippers *Ariel* and *Taeping* racing neck and neck up Channel. Dutton's versatility also embraced naval vessels and occasionally yachts, for this sport had renewed its grip upon the wealthy by this time. He recorded a period of rapid change and experiment in every aspect relating to the sea-going ship; a change from sail to steam, paddle to screw propeller, the refinement of the sailing ship in a forlorn and final effort to beat off the challenge of steam and a parallel transformation in construction brought about as iron and steel replaced oak and elm.

This period, the middle decades of the nineteenth century, was also the golden age of the print-makers, and their work, celebrating the achievements of a prosperous and expanding industry, found a wide acceptance. There was W. J. Huggins' long-lived contemporary J. C. Sketky (1778-1874) who particularly deserves mention, John Ward (1798-1849) and W. F. Stcttle (1821-97) both of Hull, and H. J. Vernon, all who produced lithographs of shipping, many of them ship-portraits. They were framed and hung in the offices of ship-brokers and agents, chandlers and insurers, in the homes of captains and ship-owners. There

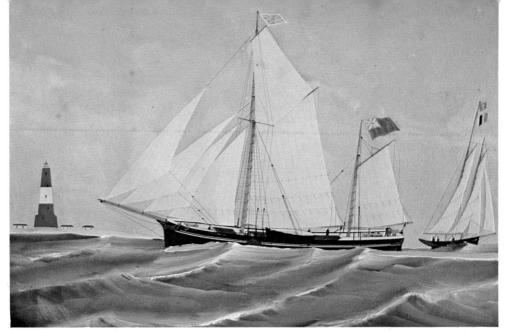

*A. de Clerk, Antwerp*          *Water colour on paper*          *22 x 32 ins.*

'*Carisbrooke Castle* of London, William Ward master'. This ketch-barge was launched by the master barge-builders, J. & H. Cann of Harwich. She could load cargoes of over one hundred and fifty tons on a draught of seven feet. Antwerp was frequently visited by the barges with cargoes of china-clay and tiles were loaded for the return voyage to the East Coast.          *Mrs Palmer*

*A. de Clerk, Antwerp*          *Water colour on paper*          *22 x 32 ins.*

*Southern Belle* Capt. Peck. The painter has produced a lively impression of a spritsail barge shortening sail in heavy weather. The brailing mainsail could be handled by a small crew and the topsail brought down to the mast-head to shorten sail further. This type of barge was known as a mulie for she combined the 'spritties' gear on the main mast while adopting the mizzen mast and sail of a ketch, similar to the *Carisbrooke Castle*.          *Author*

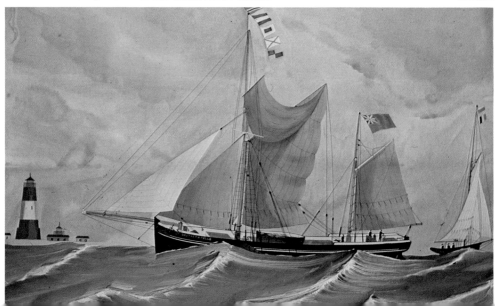

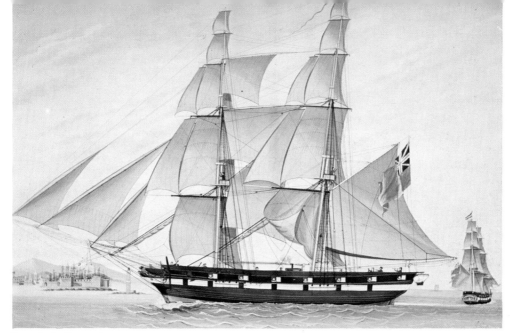

| *Joseph Fedi, Leghorn* | *Gouache on paper* | *18 x 23 ins.* |

'*Lion* of Yarmouth John Hex, Master'. Considered to be the fastest brig sailing from Yarmouth, setting skysails and carrying immense headgear she traded to Leghorn and Venice with barrelled herrings. She met her match in a race against the *Vivid* to Venice in the depth of winter in 1835. The *Vivid* arrived a whole week ahead of the *Lion*. The *Lion* of 178 tons is shown well equipped with guns and indicates that the painting probably dates from the Napoleonic Wars. The gun ports shown opening fore and aft in two sections are of interest. *Miss A. E. Colman*

| *Anon, Naples* | *Gouache on paper* | *19 x 22½ ins.* |

'Brig *Eliza* of Yarmouth, Robert Capp Commander departing from Naples.' Less of a racer than the *Lion*, the *Eliza* was another of the fleet of Yarmouth brigs employed sailing out herrings to the Mediterranean and returning with dried fruits. The driver (the fore and aft sail on the main mast) is shown 'scandalised', a rough and ready way of reducing sail.

*Norfolk Museums Service, Great Yarmouth Museums*

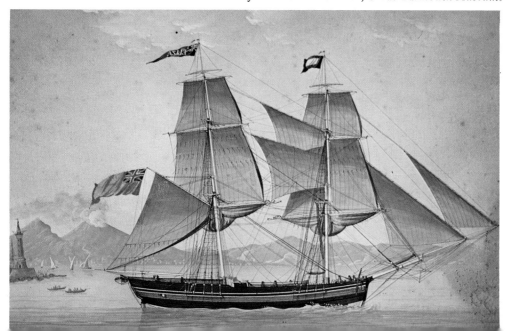

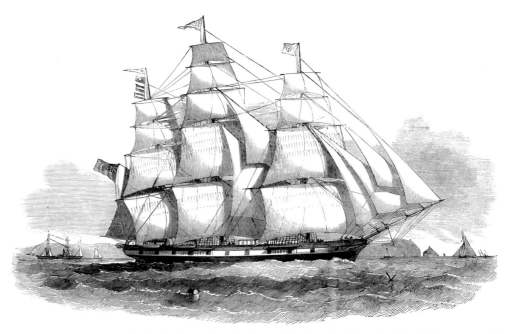

A wood engraving of the 'new Australian Emigrant Packet-ship *Ben Nevis'* which appeared in the *Illustrated London News* of 4th September 1852. This is typical of the high quality of the original illustrations that regularly appeared in the periodical before the introduction of the half-tone block. It provided a distribution to a particular style of representation of the sailing ship which was widely imitated.

The *Ben Nevis* was built at St. John, New Brunswick, of 1,420 tons and had provision for 650 passengers; she formed one of the White Star line of packet-ships. On her bow she carried a figure-head of a Highlander in full costume and the Caledonian Arms on the stern.    *Author*

they served as an accepted standard of excellence for all who essayed a ship-painting. On the other side of the Atlantic the same flood of prints occurred. Amongst others, J. H. Bufford, N. Currier of Spruce, New York State, and later Currier and Ives produced them; the paintings lost some of their refinement in colour and detail in the process, but gained a lively vitality which seems entirely appropriate to the Yankee clipper schooners and brigs that they portrayed.

To meet the full approval of their patrons, who held that exactness must be valued above all else, the print makers and the painters realised that nevertheless there was an added attraction in the picture which was produced with an awareness of style as well as technical knowledge. The style which we recognise as that of the Romantic Movement was the last revolution in the visual arts to influence the artisan painters of ship-portraits. Its characteristic innovations were rapidly adopted, and these in turn hardened into conventions as rigid as any of the eighteenth century, remaining a constant factor recognisable in the humblest compositions by painters far removed from academies and galleries. The chiaroscuro of sun and cloud, a blending of the vigorous and subtle, the dramatic lighting of the

central subject, all set against the grandeur of natural forces, struck a sympathetic chord in the hearts of even unsophisticated patrons.

At another level, beginning in the forties, wood engravings appeared regularly in the Press, celebrating the launch or arrival at the end of a maiden voyage of an especially interesting vessel. Those appearing in *The Illustrated London News* were particularly influential. These were engraved from drawings made by E. Weedon and they employed the conventions of showing a vessel isolated and dramatised in a manner ultimately derived from Brooking and Philip de Louthenbourg of the eighteenth century and then perpetuated by Buttersworth and Huggins in the nineteenth. These wood-engravings augmented the prints and provided a readily available model for instructing innumerable imitators. Pier-head artists and the more refined ship-portraitists such as James Harris of Swansea (fl. 1846-76) and W. B. Spencer (fl. 1840-70), who recorded the tea-clippers, but with less sensitivity than Dutton, drew upon this source, consciously and unconsciously.

There were as well as these influences, directly didactic sources from which embryo artists might seek instruction. James Carmichael (1800-1868), one of a

*John Stewart*                    *Oil on canvas*

Barque *Mindora*. A typical ship-portrait of a deep-water sailing ship of the later part of the nineteenth century. The artist has perhaps made more play with cast shadows of sails than many of his less sophisticated contemporaries. The *Mindora* has the typical white turned-wood rail round her poop and heavy channels of the Nova Scotian-built vessel of the period. She was launched in 1865 at St John's New Brunswick, as a ship and was later converted to a barque, sailing from Sydney, New South Wales.                    *Simon Carter Gallery*

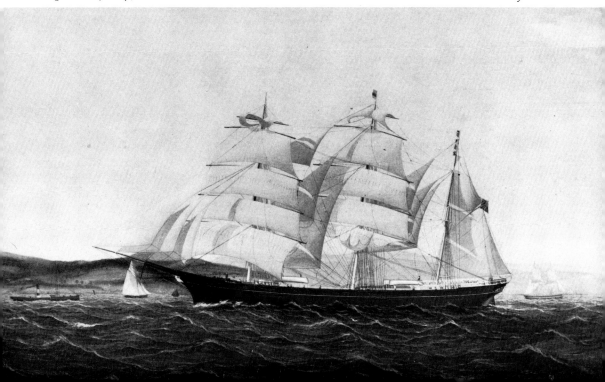

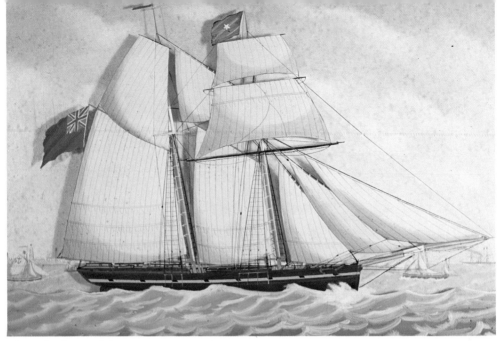

| *Alexander Lamaetiniere* | *Oil paint on glass* | *18 x 21 ins.* |

*Brothers Friend*, commander Wm. Lewcock'. A very fine example of a glass painting, originating from Dunkirk and dated 'Juillet 1854'. It is framed with the backing some distance from the glass to give a three-dimensional effect. The schooner was built at Yarmouth in 1827, was of 68 tons and when the painting was made was owned at Southwold.  *C. E. Lewcock*

| *Anon.* | *Oil on canvas* | *16 x 21 ins.* |

*Reform* of Plymouth. A topsail schooner built at Plymouth in 1832, the *Reform* was lengthened in 1843 by having a new centre section built into her hull and then sheathed in yellow-metal. She traded to the Mediterranean, and ended her career owned at Barrow.  *J. N. C. Lewis*

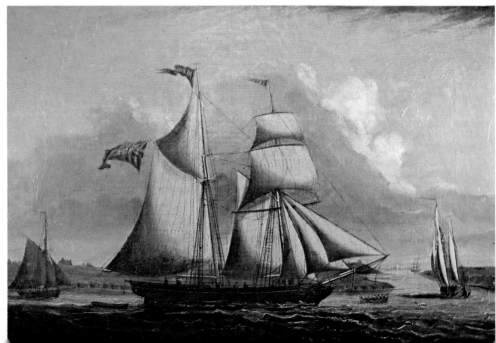

group of northern painters who worked in oil and water colours, producing sea-scapes and commemorative pictures of maritime occasions, published *The Art of Marine Paintings in Water Colour* in 1859. It contained direct instruction in composition combined with engravings to copy. Others, on a more modest scale, were published by Edward Duncan (1803-81).

Dutton's long working life, whose most prolific period covers the years between 1845 and 1879 approximately, spanned the introduction of photography. Photography made rapid technical strides, fundamentally affecting the visual arts, after 1850. The influence of the camera may be perhaps detected in Dutton's later work, and indeed others of the same period, when he explored with increasing ingenuity more informal compositions than the 'under-full-sail' profile view tra-ditionally accepted amongst ship-portraitists. However, it was many years before the photograph could offer serious competition, except that of novelty, to the appeal of a colourful and carefully painted portrait. A photograph of a big square-rigger at anchor in a roadstead, with yards trimmed and sails given a harbour-stow, might possibly offer an attractive alternative to the traditional artists' work. But a photograph of a predominantly fore-and-aft rigged vessel of modest tonnage, lost in the corner of a grimy dock, even if recorded with all the refinements of accuracy inherent in the new technique, could hardly make a composition worthy of display above the South Sea coral and engraved walrus tooth on the wall above the chimneypiece. It was not until the nineteen hundreds that photographs of vessels under sail became at all commonly available and then the photographer required ideal conditions to produce his picture. Even then problems occurred. Captured by the cold eye of the camera a badly stayed mast, an Irishman's pennant aloft or a shaking luff on the fore-sail would in the eyes of the conscientious captain provide an everlasting irritation. Far better a picture by an understanding artist who could be relied upon to eliminate such evidence of chance error or enforced economy.

Brig. Illustration from the nine-teenth century book *Sailing Vessels.*                *Author*

65

# Identification

To IDENTIFY, or even date, an apparently anonymous vessel in a painting is at once a baffling and fascinating challenge — even to set out to trace the history of a ship whose name is known is often far from straightforward. The naming of individual ships dates from at least late medieval times, but it was not until the Registry Act of 1786 became law that it was mandatory for owners to see that the name of a vessel was carved upon her stern, no mention was made of the bow, "in white or yellow letters upon a black ground, the letters not to be less than four inches in length". The introduction of the regulation was part of the anti-smuggling laws of the period. Prior to that date, and indeed for years afterwards, it is exceptional to find in a painting of a vessel shown in profile any direct indication of her name at all — as may be noted in a number of the paintings reproduced here. Only where the pleasing conceit of including on the canvas a second view of the same vessel, shown stern-on in addition to one in profile, may a name sometimes be read. Even this assistance to identification cannot always be relied upon for during war the privilege was granted to the owners of square-rigged vessels that their vessels' names might be erased.

The pleasant tradition of celebrating the launch of a vessel by providing it with a long pennant emblazoned with its name probably dates from this time and continued until the end of the days of sail. For smaller vessels it provided a ready-to-hand way of signalling its identity to a passing ship when entering a port or advertising its presence to merchants and officials when lying in a dock. Unlike a painted and carved name on the bow, a flag had the added advantage of being easily struck and so providing a vessel with a useful anonymity, should the situation demand it.

This pennant is often shown in paintings although it is less usual in the larger latter-day windjammers. But once the name of a vessel is established there still remain considerable difficulties in ensuring an accurate identification which is the key to discovering further details. There was an astonishing fixation on certain names, waxing and waning in their popularity as fashions changed throughout the nineteenth century; not until very recently did the Register of Shipping forbid the duplication of ships' names. The 1890 Merchant Navy List gives no fewer than fifty-four vessels christened *Ellen*, closely followed by *Pearl* which was carried by some fifty-two, ranging in rig from brigantines to yawls. Earlier in the century the more exclusive Lloyds List of 1857 gives twenty-five *Victorias* from which to

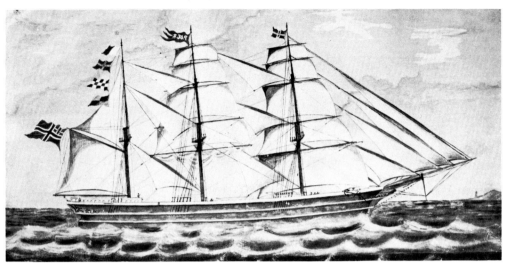

W. L. Alfreds                    Gouache on paper                    23½ x 36½ ins.

'Barque *Quos* of Kragerve, G. Olsen Master Entering Sunderland Harbour August 13 1874 Wind S'. This cheerful representation of a Norwegian barque is notable for the flags shown aloft. The ensign at the gaff is that of the combined nations of Sweden and Norway while the flour-flag hoist at the mast is the identification signal, allocated to the ship. These are followed by the house flag at the main and then the national flag on the fore.

*Sunderland Museum, Tyne and Wear County*

choose a likely candidate. Ships proudly named after their owner or owners present much less difficulty; there is unlikely to be more than one *Dizzy Dunlop*, a Welsh schooner of the 'seventies!

It became the accepted practice by the eighteen forties to carve and paint a ship's name upon a panel carried on the quarters aft above the bulwarks. This was a practical expedient for in this position it made identification relatively simple when the craft was lying in dock and was unlikely to be obscured by sails when at sea. Only occasionally does one find a ship-portrait dating from the first half of the nineteenth century depicting the name of the vessel upon the bows and then it is usually shown painted or carved relatively inconspicuously on the trail boards supporting the stem-head at the bow. The change came with the Merchant Shipping Act of 1876. After that date it was made compulsory that all British registered ships were to be clearly identifiable with their name painted on the bow, the letters of the name "to be at least four inches long; white or yellow on a dark ground or black on a light ground."

It was said that the sinking of the emigrant ship *Northfleet*, with a tragically high loss of life, hastened the change. When she was struck down while at anchor off Dungeness by a steamer at full speed, which then made off, the watch on the deck of the *Northfleet* had no way of identifying the culprit. An otherwise undated and unnamed painting of a vessel may sometimes by named by recourse

to a study of the flags she flies. These were understandably seized upon by the artist to add movement and colour to his composition and every possible piece of bunting that the vessel possessed and could legitimately hoist aloft was frequently portrayed. Nevertheless the artist made sure that they were shown hoisted in accordance with a strictly maintained protocol.

Many of the smaller vessels, and these often are the subject of the most lively painters, were owned by individuals or groups of individuals who did not aspire to a houseflag to indicate their ownership. However, houseflags became more generally adopted, even among the smaller fry, as the nineteenth century wore on and fleets were built up. The number of houseflags is legion. Beginning in 1800 the port of Bremen alone can claim two hundred while Liverpool's are without number! The books of Basil Lubbock, listed in the bibliography, may be of assistance in tracing and identifying a vessel's houseflag. But the work of detection is not simplified by the fact that firms changed the design of their flag, due either to mergers or new management, while individual vessels of the same firm were known to fly their own variant. The houseflag may be identified in a portrait of a British vessel as the flag flown at the mainmast head of a three-master and on the

*E. Wilkinson*                    *Water colour on paper*                    *18 x 30 ins.*

Barque *Windrush* 1891. One of the last sailing ships built at Sunderland and built for R. H. Gaynor whose house-flag she flies at the mainmast. The *Windrush* was later sold to a Boston, Mass. firm. The sail plan is interesting for she carries a single topgallant on the foremast and double topgallant on the main, while the spike-bowsprit has replaced the bowsprit and jib-boom of earlier days.                    *Sunderland Museum, Tyne and Wear County*

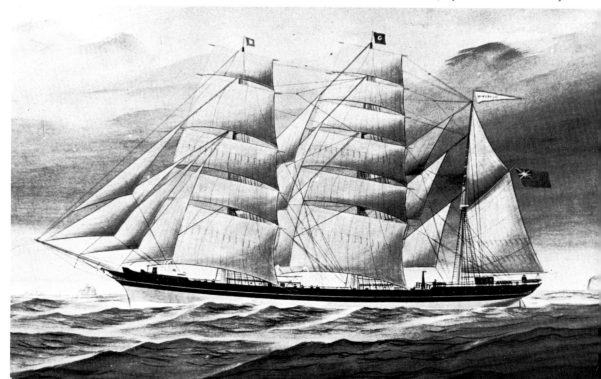

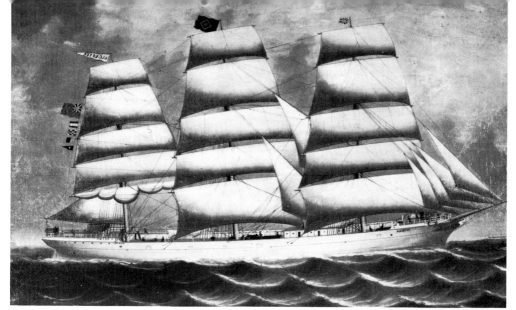

*Anon*                                       *Oil on canvas*

Ship *Alcester* of Liverpool. A steel ship built at Greenock in 1883 of 1,597 tons and owned at Liverpool by R. C. Haws. The painting well illustrates the flag-hoists at their appropriate points. She is typical of the big steel carriers built in the 'eighties, moderately rigged, with no pretensions to speed but loading bulk cargoes of grain, timber, case oil and coal.

*Mersey County Museums*

foremast of a brig. The honourable exception to this rule is the firm F. and J. Brocklebank, of Liverpool, who commissioned many fine paintings of their extensive fleet. Their white and blue houseflag was, by long-standing tradition, carried on the foremast. It is said to have perpetuated the tradition that Brocklebank's ships acting as privateers and carrying Letters of Marque during the Napoleonic Wars reserved the mainmast for flying the King's pennant. Paintings of their ships from the days of sail are well known and illustrate this distinctive touch; in all other British registered ships it has gradually been accepted that the foremast was the correct place for the Trading Flag, which is the ensign of the country of the ship's port of call, to be flown.

Smaller vessels, while not aspiring to a houseflag, could sometimes make good the deficiency by wearing the flag indicating their membership of one of the numerous mutual insurance groups of the sea ports large and small. These had a local loyalty and recruitment and usually the flag's design involved the number allocated to the vessel by the association. While etiquette decreed that it should only be sent aloft in port, and if flown at sea it indicated that the vessel required assistance from a fellow member of the same insurance association so that claims for salvage might be reduced, the painters allowed themselves a certain latitude in this direction.

A pennant or flag carrying the compass and square or other more esoteric symbols of the Masonic Order is occasionally shown, indicating that the captain was a Lodge member. This again was usually only sent aloft in port; apparently at some risk, for an old coasting skipper complained to me that it usually cost him at least five sovereigns in loans to his fellow-members who had been impoverished by a long wait for a cargo.

The Mercantile Marine Jack, a flag originally introduced by Captain Marryat into his 1817 code of signals, was in fact a Union Flag with a white border, officially intended to indicate that a pilot was required. Commonly flown on the foremast, it was used as an excusable attempt to display patriotism and avoid prosecution by commanders of British registered vessels, in order to circumvent the somewhat perverse rule that the Union Flag must on no account be flown by a British merchant ship or yacht, and was so recorded by ship-portraitist.

The national flag is usually carried at the peak, that is to say at the extremity of the gaff on the mizzen-mast, or from a flagstaff on the stern. The official designation of the Red Ensign to the British merchant navy dates from 1864, although for at least half a century before this it had been commonly used by trading vessels and is easily identified. Other national merchant flags may be more difficult to place, deriving from European nation-states and ports absorbed during the nineteenth century into larger national identities. Large merchant fleets, many of them the smaller traders commanded by captains who commissioned portraits of their ships, were owned by Hamburg, Stettin and Bremen. Each of these ports, and others in the same area, as well as some bordering the Mediterranean, had its own distinctive merchant flag which passed out of use as a result of the political changes in 1870 or even later. From 1844 until 1898 the combined countries of Norway and Sweden had their own, now extinct, merchant flag.

Other bunting shown in paintings is usually a four-flag hoist of signal flags making up the official 'Code Signal' which the Merchant Shipping Act of 1854 made available to seagoing British-registered merchant vessels. This was stated upon the ship's Certificate of Registry and entered in the Mercantile Navy List published annually since 1851.

The Commercial Code of Signals, the code most frequently depicted in sailing-ship paintings, was first issued by the British Board of Trade in 1857. It was a code of signal flags based upon the far older code designed by Captain Frederick Marryat, dating from 1817 although revised in 1841. Marryat had designed them with care, so that they did not clash with the flags already in use in the Royal Navy. The Commercial Code flags are usually flown at the mizzen truck or the peak of the mizzen-gaff, below the ensign. These may be interpreted into alphabetical letters with reference to the chart of the 1857 code flags. This individual flag hoist enabled a vessel to identify itself to the fifty or so Signal

Stations at points on the coast, both in Britain and overseas, so that it could be reported by telegraph to the ship's owners. It should be noted that a four-flag hoist beginning with a red burgess indicates a place-name and would be flown by a ship communicating her destined port to a signal station or a passing ship.

Correctly interpreted, the individual Code Signal of a vessel gives conclusive evidence of her identity when checked against the appropriate entry in the Mercantile Navy List. The exceptions are the small trading vessels and tugs intended only for river and estuary work, which were never allocated a Code Signal. Indeed, a few of the smallest were never registered officially at the Customs House of their port, their owners considering it unlikely that they would ever venture outside river limits.

Marryat's Code had a competitor in the North West ports where the Trustees of the Liverpool Docks in 1826, established their own code, which, with variations, lasted until the 1860s. Although it had its own code-book it depended upon Marryat's flags. Other ports, much smaller than Liverpool, had private forms of signalling to establish identification between the port's vessels and pilots. These were quite ingenious and sometimes appear in paintings; double black discs hoisted to the yard-arm, or even the jib-boom end, are recorded.

Marryat's Code had a long life and continued in use for some two decades after its official replacement by the later Commercial Code of Signals, renamed the International Code of Signals in 1871. With a nicety of Victorian forethought the Commercial Code omitted from its range of flags, each of which was of course related to a letter of the alphabet, all vowels and the letters X, Y, and Z. This was to avoid "every objectionable word composed of four letters, or less, not only in our own, but the other languages".

The end of the nineteenth century saw steamships, as yet unequipped with wireless telegraphy, replacing sail and the new technology demanded a wider range of signalling facilities. A new enlarged International Code was introduced, although vessels retained the same Code Signal as registered in the Mercantile Navy List. By this time it was considered that captains and crews might be trusted to overcome the temptation to misuse the code and flags were allocated to all twenty-six letters of the alphabet. This revised code became mandatory on 31st December 1901, after running concurrently with the older system for one year. Although it does not concern us directly, for the day of the pier-head painter had passed before then, it is worth mentioning that a further change took place in 1934.

Besides the more obvious evidence provided by flags and augmenting the clues provided by the painter's style, there is the possibility of details of the rig and hull depicted providing information. The next section will provide material, I hope, which may be used to interpret and date a ship-portrait in this way. It is, however, perhaps worth stating here a few general guide lines.

Generally speaking the hulls of merchantmen tended to become longer and lower by the middle of the nineteenth century, when the clipper bow with its forward-sloping rake was introduced. The sharper bow lines of the hull forced the ship-designers to place the foremast further aft and the enormously long bowsprits and jib-booms gradually became shorter in length, with better balanced sail-plans. The introduction of steel wire in the 'sixties enabled standing rigging to become apparently lighter, if judged from a painting. Sail-plans were modified. The introduction of double topsails in the eighteen-sixties spread rapidly and in the nineties double top gallants followed, both developments which made the work aloft when reducing sail less arduous for the crews, reduced for the sake of economy. Skysails and stunsails were rarely seen at sea after the end of the eighteen-eighties.

The spike bowsprit replaced the complex staying and cordage associated with the older bowsprit and jib-boom, sometimes nearly half the length of the hull, at about the same date. The barquentine rig emerges in the 'sixties of the last century and the three and then the four masted barque becomes general ten or twenty years later. The painting of hulls with false gun-ports, originally a subterfuge to deceive French privateers during the Napoleonic Wars, survived until the war against the Kaiser while decoration at the bow gradually withered as the nineteenth century drew to its close, although figure heads were common until the end of the days of sail.

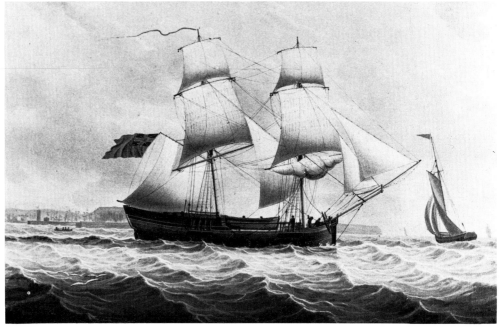

*H. Collins*         *Oil on canvas*        *Simon Carter Gallery*
Brig, dated 1814

# HISTORICAL REVIEW

Although we begin our account with a representation of a small anonymous vessel, loading only a few score tons of cargo, it is a painting by a master ship-portraitist of a subject that is evocative of the time. It is possible that her captain, if one of the old school, would have called her a brigantine, but by 1814 the title "brig" was emerging as a commonly used term. It was, however, another thirty years or so before the name "brigantine" was revived to describe a two-masted vessel that was square rigged on the fore-mast only. These niceties should not obscure the fact that Collin's painting shows, with admirable clarity, how the lowest common denominator of our merchant marine appeared between approximately 1750 and 1850. While the great Indiamen captured the public interest, the work done by the brigantines and snows made possible our mercantile expansion by an unspectacular fetching and carrying.

They and their sort developed in hull and rig but slowly. The technology of hand-woven flax canvas and hand-made rope, of adze and frame-saw, smithy and carpenter's shop, placed a limit on change that was difficult to overcome. But the resulting vessel built from these limited resources and skills, even if it occupied the crew at the pumps during every watch and was incapable of working well to windward, eventually provided her owners with earnings and profit which laid the keels for more efficient replacements, as we shall see.

Exactly why the eighteenth century seamen tolerated the open decks forward of the main-mast it is difficult to understand. Perhaps planked-up bulwarks were too vulnerable to damage by the sea with the resulting torn-out stanchions leading to dangerous leaks. It was, in all truth, a common enough arrangement. The lack of staying to the jib-boom makes one question the conservatism of the riggers; martingales (or dolphin-strikers) under the bowsprit end were only gradually becoming common. It is something counterfeiters of paintings can rarely resist adding and is invariably too early in date to harmonise with the rest of the detail. Collin's little brig is, however, well up with fashion in one respect. The square-sails are attached to the top of the yards by a rope or iron jackstay; most vessels at the time secured them with robands so that the sail hung beneath the spar.

At the beginning of the nineteenth century some colliers and most whalers were ship rigged, as well as the much larger East and West Indiamen. These later vessels attracted the attention of the artists who are probably beyond the scope of our present book. By the time such vessels as the *City of Carlisle* was launched in 1853, however, the lesser artists were finding that portraits of the bigger vessels were demanded by their less affluent patrons. The portrait of the *City of Hamilton*, painted some ten years later, was probably produced for a master mariner enjoying the gratuity resulting from a successful China voyage.

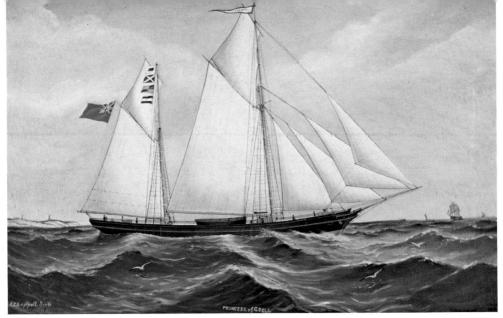

*Reuben Chappell*            *Oil on canvas*            *21 x 35 ins.*

*Princess* of Goole. One of Chappell's earlier paintings produced when he was working in oils. The *Princess* was typical of the trading ketches which became the most popular rig for small sailing vessels at the end of the sailing-ship era. The *Princess* was built at Goole in 1879 and owned there.                                                                          *Robert Malster*

*Reuben Chappell*            *Water colour on board*            *14 x 20 ins.*

Ketch *Ulelia*. A typical water-colour of Chappell's, probably dating from the nineteen hundreds. The ketch was built as a fore and aft schooner, at Truro in 1877, intended for the North Atlantic trade to Newfoundland. Re-rigged as a ketch in 1908 she became a coaster, owned in North Devon. Unlike many of her contemporaries, the *Ulelia* never became an auxiliary and was lost on the rocks when entering Rhoscarberry, Ireland, in 1930.            *J. H. Clegg*

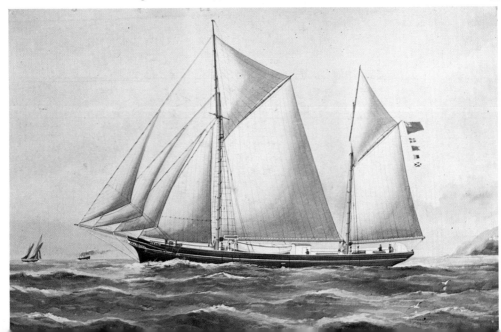

*Tom Swan*           *19 x 24 ins.*
*Water colour, some body-colour and ink*

'YH 779, R. Taylor Master 1897'. A scene of the herring fisher, the 'convertor' smack YH 779 is hauling her nets with the main mast lowered and the mizzen aloft to keep her head to wind. The significance of the whale in the picture is somewhat obscure, but Swan considered its presence indicated the likelihood of a good catch.
*Norfolk Museum Service,*
*Great Yarmouth Maritime Museum*

*Anon. (Neapolitan)*       *18 x 22 ins.*
*Gouache on paper*

'William'. The barquentine *William*, built at Ipswich 1872 and owned at Yarmouth, is pictured in a style that owes a great deal to the tradition of 'votive' paintings. In such extreme conditions of sea and weather the multiple division of the barquentine's sail-plan enabled a caption to balance a minimum of canvas to a nicety and maintain some progress in relative safety.       *Author*

*Anon.*     *Oil on canvas*     *12 x 18 ins.*

An unsigned portrait of a brig, C, 1830. The date is suggested by the quarter galleries and single topsails. The stunsails, really temporary extensions of the square sails on especially rigged-out booms, are shown well.       *J. N. C. Lewis*

Miles Walters                         *Oil on canvas*

'*Acasta* off the Needles'. The post Napoleonic War merchant brig, complete with skysails on the main-mast and stunsails drawing on each mast, makes an interesting contrast to the austerity of the subject of Collin's painting. The huge sail-plan of the Revenue cruiser is on the same generous scale.                  *Simon Carter Gallery.*

Despite the growth of the average tonnage of sailing ships it was still a profitable venture to launch and trade with relatively small vessels throughout the nineteenth century. Although obviously the paintings of these ships record their visits to Continental and Mediterranean ports; voyages to South America, the Indian Ocean and Africa all figure in old leather-bound cargo books relating to brigs and brigantines of only one and two hundred tons. It was found that the brig's sail-plan in expert hands, while having some advantage in negotiating the un-improved rivers and estuaries, could be expensive in both men and materials. The more economical brigantine rig was slowly evolved as these pictures show. In the 'sixties, probably imported as an American innovation, the barquentine rig made its appearance and was used in vessels of ever-increasing size. With its single square-rigged mast, as well as two others carrying fore and aft canvas, the barquentine became more common as the brigs and smaller barques passed on.

Although three-masted barques were known in the eighteenth century, the barque rig reached its greatest popularity with ship-owners during the nineteenth. They were built at the emerging shipyards of the North as iron and then steel became the predominating materials to be used in shipbuilding, but also at the older ports all round the coast from Nevin to Yarmouth where wooden vessels could still find buyers. These vessels tended to pass into foreign hands as more

modern tonnage was purchased by British owners and they came to be found in the Scandinavian timber and ice trade to the East Coast and London.

Disaster and misfortune were never far away at sea, and wrecks occurred upon a scale and with a frequency that we now find it difficult to appreciate. For those who survived, it provided dramatic material for a picture which recorded the escape. As well as the more spectacular wrecks and losses by storm, there were the collisions at sea due to human error, inadequate navigational aids or the sheer exhaustion of the commander and crew. More infuriating were the damage and strandings caused by the difficulty of manoeuvring unwieldy vessels in rivers and docks. The general introduction of steam towage, which began on the North East coast in the eighteen twenties, had become general by the 'forties and assisted in solving some of these problems. It made it possible to build much larger sailing ships for they could now rely on steam-tugs to assist them in docking, instead of the wearisome process of warping, and by providing a good offing for an outward-bounder when her captain was faced with a head wind.

Towards the end of the sailing ship era it was very unusual for a square-rigged vessel to be under way under sail alone within estuary limits and tugs would await homeward-bounders many miles outside every large port. Tugs and their crews were not slow in earning themselves reputations, of both sorts, and they often engendered a loyalty from the crews of ships that employed them. Frequently owned on the share system, with a family basis, these tugs were often portrayed

*Robert Willoughby*  *Oil on canvas*  *26 x 38 ins.*

'Whaler in the Arctic'. Unfortunately the name of this Hull whaler, shown in two positions, has been lost. We may date it from the later part of the Napoleonic Wars, for whalers were forced to arm themselves against privateers, while the martingale on the bowsprit suggests a date after 1800. The flag flying on the mizzen is to signal that the boats are to return to the parent ship at the end of a successful hunt.  *Kingston upon Hull City Council, Ferens Art Gallery*

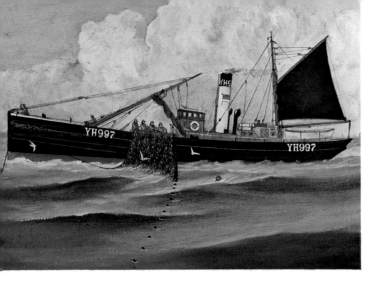

*Mowle and Luck*          *14 x 23 in.*
*Oil on board*

Steam drifter YH 997 (c. 1912). Th[e]
painting is typical of the work produce[d]
by K. Luck from the photographs [of]
Mowle. The long drift-nets are show[n]
being hauled at dawn while the drift[er]
rides to her mizzen.        *J. N. C. Lew[is]*

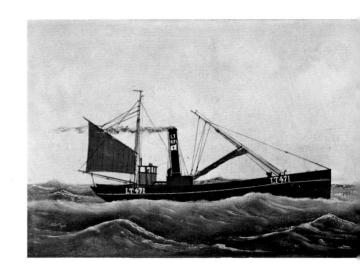

*George Race*    *Oil on board*    *12 x 19 ins.*

Steam drifter LT 471 (c. 1910). An early
Lowestoft steam drifter on passage to the
fishing grounds with the foremast lowered.
                      *J. N. C. Lewis*

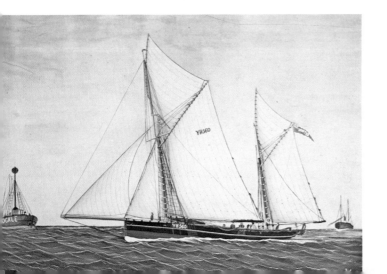

*Tom Swan*            *19 x 24 ins.*
*Water colour and ink line*

'Sailing trawler *Hunter* YH 560, 1897'
The sails of trawlers were only dresse[d]
brown after a season's use and some
light summer suits remained white. Yar[-]
mouth trawlermen carried their beam
trawl on either quarter, despite the traw[-]
lerman's conviction that the port hand
position would bring misfortune.
                 *Norfolk Museum Service[s]*
                     *Great Yarmouth Museum[s]*

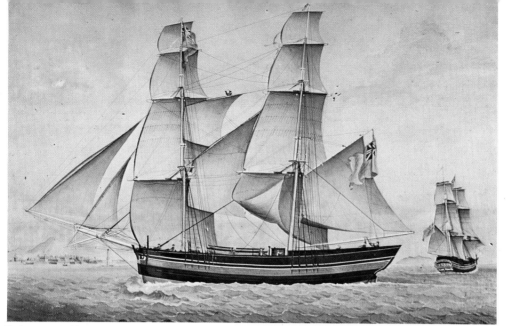

*Guiseppe Fedi, Livorno*  *Gouache on paper*  *17 x 23 ins.*

'The *Maria* of Great Yarmouth, James Love Commander Entering the Port of Leghorn'. The outward voyages to the Mediterranean from Yarmouth consisted of cargoes of barrelled herring, fruits of the autumn herring harvest. Grain from Marseilles, figs from Kharina or currants and olive oil from Naples were regularly shipped back. The scraped and varnished wale along the hull of the *Maria* provides a distinctive touch to the little vessel.  *Miss A. E. Colman*

*Anon. (Neopolitan)*  *Gouache on paper*  *18 x 25 ins.*

'*Fortitude*, Ipswich'. An interesting example of the early rig of an ocean-going topsail schooner. The *Fortitude* was built in 1826 at Ipswich by Bayley and then in 1833 lengthened by ten feet. The upper and lower staysails between the masts add an unusual addition to a schooner's sail-plan.  *J. H. Clegg*

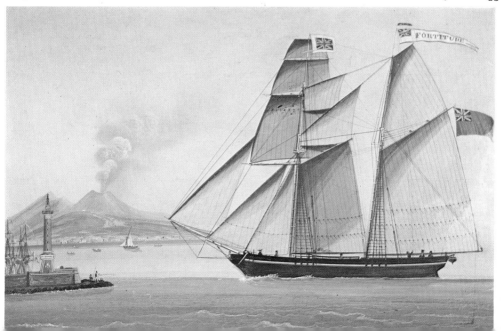

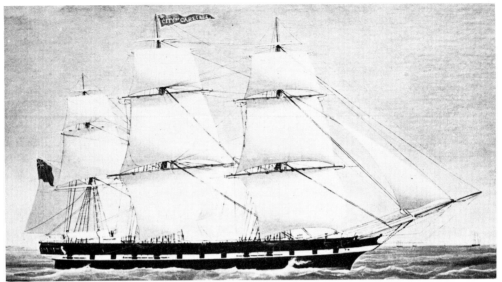

*E. Poulson*                    *Oil on canvas*                    *25 x 37 ins.*

*City of Carlisle.* The largest ship built by Robert Thompson, Southwick, Sunderland, up to that date, launched in 1853 and transversely strengthened with iron, an innovation at that time. She took troops to the Crimea and later traded to China.

*Sunderland Museum, Tyne and Wear County*

*W. Webb*                    *Oil on canvas*

'*City of Hamilton* of London off Dover 1867'. A semi-clipper, she was built at Aberdeen in 1850, of 524 tons and owned by Edmundstone of London. She has the huge single topsails usual at the time of her launch, although by the date of the painting double topsails were being introduced.                    *Simon Carter Gallery.*

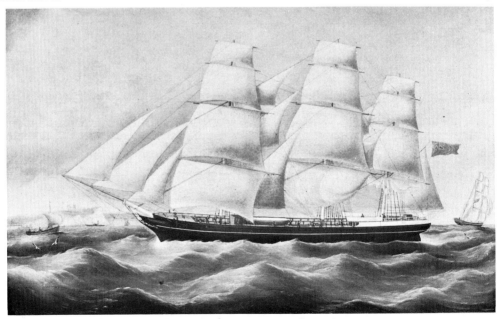

by "pierheaders". But the paintings of tugs lack the instantaneous appeal of the sailing ship portrait and far fewer survive to the present day, although some, particularly those of paddle-tugs, make attractive compositions.

To turn from the likeable smoke, steam and utility of the tugs to sail makes a pleasant contrast and the third quarter of the nineteenth century saw the full-rigged ship reach its zenith. Although the tea-clippers were the finest of the breed, ships carried emigrants to America and Australia, and our troops to India, returning home with wool and gold, jute and teak. By the end of the century great steel ship-rigged vessels, square-rigged on all three masts, of two thousand tons, were being launched, although by this time it was realised that it was both safer and more economic to design sail-plans of four masts and the four-masted barque became common by adding another fore and aft rigged mast to the traditional ship rig.

The sea-borne coal trade from the North East to the London River and the southern ports grew to be one of the most important coastal trades from at least Tudor times. By the eighteenth century it was the largest single employer of tonnage. The brig, or its relation the snow rig, was supreme in the trade after the Napoleonic Wars and numbered hundreds. The intense local patriotism of the Northern area and pride in its fleets was reflected in the numerous ship paintings

*Joseph Heard*                     *Oil on canvas*

'*John Scott* 1837'. The Whitehaven ships, although originating as an adjunct to the local coal trade, rapidly turned to voyaging further afield. The *John Scott*, built in 1835 and owned by Martin & Co. Whitehaven, made her maiden voyage between Dundee and the West Indies. The quaint upright stance of the figure-head was not uncommon in vessels prior to the introduction of the forward raking bow in the eighteen fifties.                     *Whitehaven Museum*

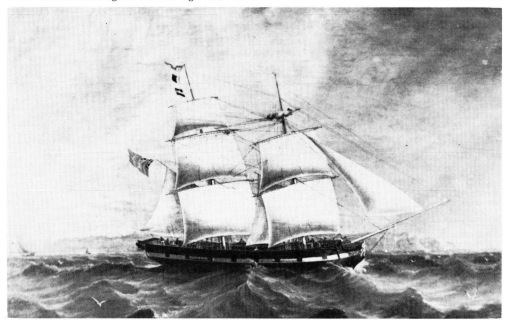

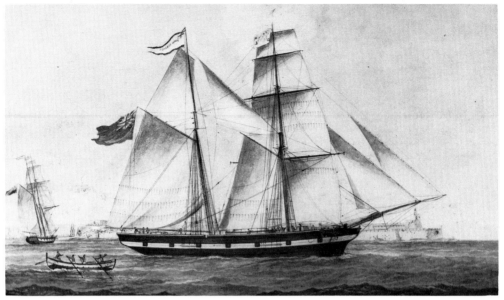

*Nicolo Cammillieri*         *Water colour on paper*         *17 x 22½ ins.*

'Brig-schooner *John Cobbold*, J. Elwood Master leaving Malta 1850'. Launched in 1847 at Ipswich, her maiden voyage took her from London to Joppa with "a church for erecting at Mount Zion, given by the Society for the Propagation of Christianity amongst the Jews and to return with corn from Egypt". The brig-schooner was lengthened in 1856 and re-rigged as a barque to be sold to the Portuguese in 1882.         *Ipswich Borough Council*

*Anon.*         *Gouache on paper*

'Brig. *Linnus*'. Built as a brig in 1857 and one of the hundreds of wooden vessels launched at Nevin, on Cardigan Bay. In the eighteen eighties she was changed in rig to a barquentine, a more economical plan in canvas and cordage for ocean voyaging. The *Linnus* survived until 1919 and all her long life she had been trading deep-sea, carrying punishing cargoes of phosphate rock from Aruba and making at least one voyage round Cape Horn.         *National Museum of Wales*

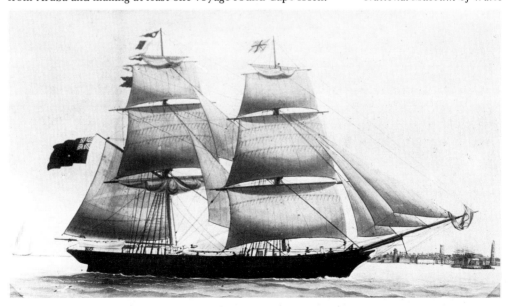

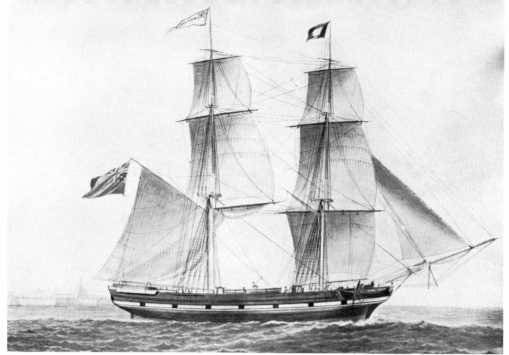

| Nicolo Cammillieri | Water colour on paper | 18½ x 23 ins. |

'Brig *Mary Brack* of Sunderland, Bryan Burletson Commander going out of Malta 1839'. The *Mary Brack* was unusually large for a brig, 323 t.g. and built at Sunderland in 1830 by John Watson. The boat shown carried on the quarters in iron davits was something of an innovation at this date and despite her deep-sea looks she has the foot of the foresail extended by a bentink boom in the manner of her less favoured compatriots in the coal trade.

*Sunderland Museum, Tyne and Wear County*

| Anon. (Neapolitan) | Gouache on board | 21 x 29 ins. |

'*Rapid* of Ipswich'. No doubt known to her captain when launched as a brig-schooner, the *Rapid* was built at Ipswich and owned there; lengthened in 1848 she was at the same time yellow metalled for southern seas. It is from this later period in her career that the painting dates and by which time she would be considered a brigantine.     *J. H. Clegg*

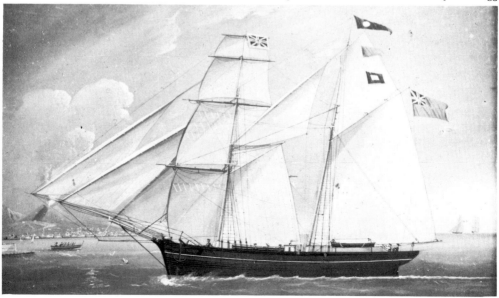

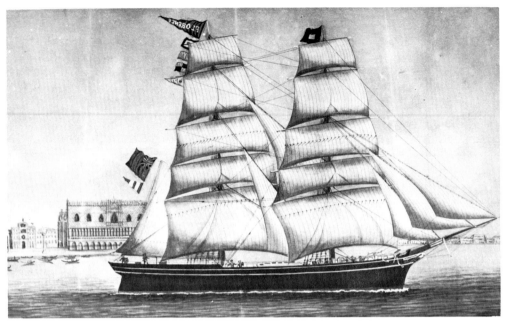

*Anon. (Venetian)*                    *Water colour on paper*                    *15 x 16 ins.*

'Brig *Florence* Venice 6th March 1874'. The *Florence* was launched in 1867 by John Gell at Sunderland, 188 t.g. and 110.5 ft. b.p., at a time when the brig rig was being replaced. The huge single topsails of the previous decade have been replaced by double topsails and the handles of a patent windlass on the foredeck are just visible. Wheel steering has replaced the long tiller of earlier brigs.                    *Sunderland Museum, Tyne and Wear County*

*J. H. Loos*                    *Oil on canvas*                    *19 x 26 ins.*

'*Renard* E. T. Tallu Commander 1856'. An early example of the true brigantine rig. The reef points along the gaff-topsail and the staysails are an interesting feature of the painting.

*Simon Carter Gallery*

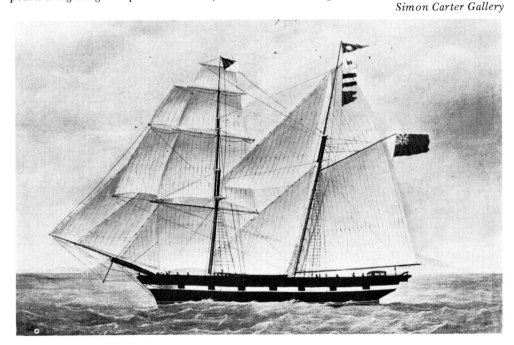

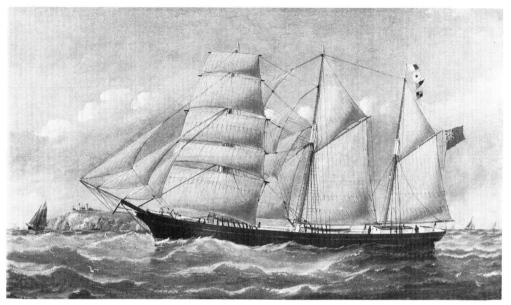

*W. M. Yorke*                    *Oil on canvas*

'*Anne Duncan* T. Bryant Master, Passing Lizard Point 14th April 1887'. A barquentine of 273 tons, the wooden *Anne Duncan* had been launched as a brig in 1855 at Ardrossan, was registered at Glasgow and her maiden voyage was to the Mediterranean. In the interests of economy she was later given a barquentine rig and sailing for some time from Falmouth, was eventually owned at London.                    *Simon Carter Gallery*

*Anon. (Neopolitan)*          *Gouache on paper*          *17 x 22 ins.*

'*William* entering the Bay of Naples 17.7.73'. An early example of a vessel launched with a barquentine rig, the *William* was built at Ipswich in 1872. The white-painted yards on the fore-mast are a distinctive feature and are unusual for a vessel of this type.          *Author*

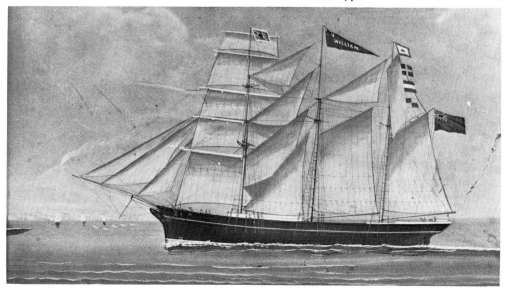

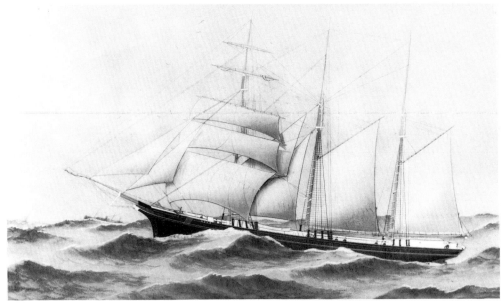

E. Wilkinson — *Water colour on paper* — *18 x 30 ins.*

Barquentine *Meda* of Charlottetown, Prince Edward Island. The *Meda* was built at Grand River, Prince Edward Island, in 1887 by John Plestid, 329 tons, and owned by John Yeo of Port Hill nearby, one of a fleet trading across the Atlantic with timber. Hundreds of wooden-built sailing vessels passed to British owners in the second half of the nineteenth century, built on the shores of Atlantic Canada. Wooden sailing ships contined to be built there until 1920.

*Lowestoft Maritime Museum*

of the colliers which still survive. The painting of the *Charles Henry* of Sunderland, showing her simple unadorned bow, with no projection from the stem head, the bentink boom under the foresail and the absence of a royal on the foremast, emphasises the essential characteristics of this class of vessel.

By the eighteen fifties a series of economic changes was threatening the industry and to meet the challenge the steam collier was developed. One of the earliest was the *Earl*, an iron screw collier launched in 1854 for the Earl of Durham at Newcastle and engined at Sunderland. Conned from the bridge, amidships the helmsman steered from the traditional quarter-deck position; a situation which, to say the least, must have caused more problems than it solved. But the real success of the screw-collier depended upon her water-ballast which enabled her to make the return voyage from the Thames without the time-consuming trouble of shipping solid ballast.

The next stage in the evolution of the steam collier is typified by the *Florence Nightingale* launched in 1878 by Osborne, Graham & Co., North Hylton, Sunderland, for J. F. Marshall & Co. Her double bottom enabled her to take in water ballast and to make the return journey from London with the maximum

economy. Sails were still fitted and used on the colliers until the end of the century.

If the full-rigged ship with its thirty individual sails represents the peak of achievement in the development of the sailing ship, the humble sloops and smacks typify the opposite extreme. Yet, they too have an interest of their own for they were in many cases the link between isolated sea-coast and river communities, some with embryo industries to be served, and a wider world. Sloops ventured across the North Sea for homely cargoes of cheese and butter, barrel staves and corn, they even crossed the Bay of Biscay to Northern Spain and the Mediterranean. They made these voyages not only immediately after the Napoleonic Wars, when the single-masted vessel was a much larger proportion of the small ship tonnage of our merchant vessels, but throughout the nineteenth century.

The scale of the enterprise they represented provided little surplus profit for such luxuries as ship-portraits, but some such pictures have survived and while they are usually of a very modest nature they are of particular interest for they record a type long since extinct in our waters. Their great gaff sail must have been a sore trial to their skippers. The hand-woven flax sail-cloth of the time was not really satisfactory raw material upon which a sailmaker could employ his subtle skill. To produce a sail which is to be hung from a yard is 'prentice work, to make one that is to be hanked to a stay requires talent, but to fit one between a mast, a gaff and a boom so that it is a thing of beauty requires a very special skill and, moreover, good, well-tried materials. Until machine-produced sail-cloth was woven,

*Anon. (British)*                    *Oil on canvas*                    *21 x 30 ins.*

Barque *Orwell* off Tynemouth. Built in 1811 as a brig at Ipswich, the *Orwell* was lengthened in 1835 and again in 1849. Even after these reconstructions she was only a modest 173 tons and yet was rigged as a barque; it was at this stage of her career that the portrait was painted. Later, her days of trading to Archangel and Italy over, she reverted to the more modest rig of a brigantine and was owned at Waterford.                    *Author*

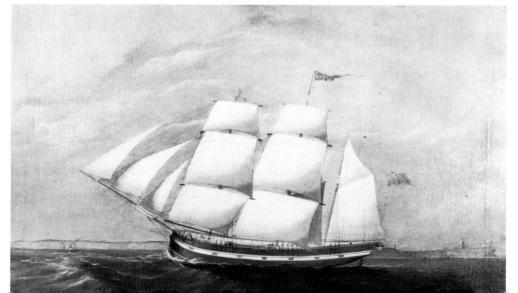

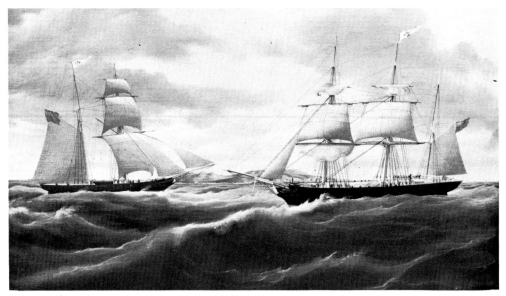

*Captain Paulson*                    *Oil on canvas*

'*Red Rose* of Liverpool'. Built at Stockton in 1843 by John Spence, she was considered to be the finest finished and fastened vessel that had been built there. She was sold to Joseph Heap and Sons, Liverpool, the following year and the painting shows their House Flag at the main-mast head. Of only 286 tons and less than one hundred feet overall, she was insignificant in comparison with later barques built on the Tees.                    *Simon Carter Gallery*

*Anon. (Neopolitan)*                    *Gouche on paper*

'Barque *Esther* of Whitehaven Entering the Bay of Naples October 1870 Capt. Cuthbertson'. This little wooden barque, typical of many unspectacular traders, was built at Liverpool in 1854. Only her double topsails distinguish her from a barque-rigged vessel of half a century before. The iron woldings round the wooden lower masts and the heavy square stern are worthy of note.                    *Simon Carter Gallery*

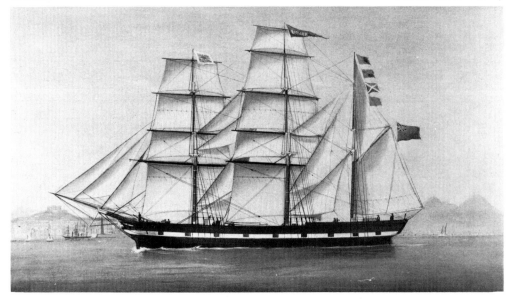

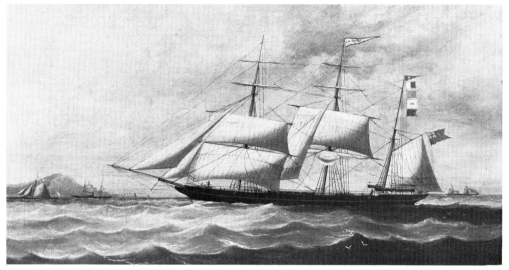

*Anon. (British)*                    *Oil on canvas*                    *16 x 24 ins.*

Three-masted barque *J. M. Kirby*. A fine example of a small barque of the eighteen-fifties outward bound under reefed topsails. The outer ends of the stunsail booms can be seen on the yards of both the fore and mainmasts.                    *Simon Carter Gallery*

*C. C. Hyatt*                    *Oil on canvas*

Three-masted barque *Villata*. A Liverpool barque of 866 tons, built at Port Glasgow in 1883 of steel. A typical latter-day vessel with an economical workaday sail-plan and a spike steel bowsprit in contrast to the long wooden bowsprit and jib-boom of the *J. M. Kirby*.
                    *Mersey County Museums*

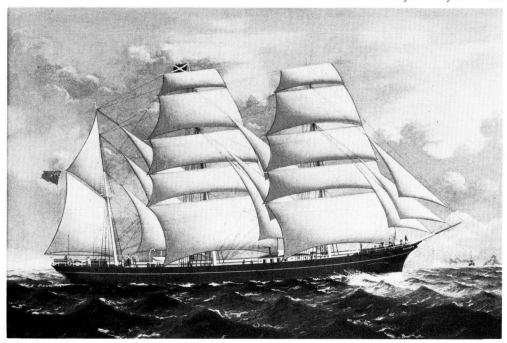

the gaff sail, despite all the efforts of the sailmaker working in his loft, was a poor tool with which to shape a fast passage or go well to windward.

Once a large, well-cut gaff sail could be produced, the schooner rig became more common and the ketch arrived, evolved from the smacks by the shortening of the long main boom and then the addition of a smaller mizzen mast forward of the tiller. Although many schooners and ketches were intended for the coastal and home trade, others regularly engaged in ocean voyaging. Taking salt to Newfoundland, returning to Europe with salted cod and then finding a cargo which would bring them once more to their home port engaged hundreds of schooners year in and year out. They survived after the big British square-riggers had gone, but were forced back to earn a precarious livelihood in home waters, their canvas and spars much reduced and last of all with auxiliary engines installed.

The pilot cutters and schooners were all powerfully built fore and aft rigged craft. This rig enabled them to heave-to and await incoming vessels while it also allowed for a minimum number of hands to sail them when the need arose. Although all pilots were licensed by Trinity House, in many areas they owned their cutters in partnerships, cruising in all weathers with the pilot jack at the mast head, to seek homeward-bound ships. They have long ago all been replaced by powered tenders and steam-cutters, although many of the sailing craft found purchasers amongst cruising yachtsmen.

The cruising yachtsman of Victorian days behaved afloat as he did ashore and conducted his pleasures upon the water somewhat over-dressed and on the same ample scale. A schooner, with or without steam propulsion, of eighty feet overall was considered the least modest vessel to be maintained for cruising and with a very few honourable exceptions ostentatious display was the order of the day. The painting of yacht portraits for their owners was an activity which belongs to another book than this. However, the paid crews, often winter-time fishermen, or merchant seamen seeking a change of employment, commissioned paintings of their employers' yachts from humbler sources and many of these have survived. A professional yacht-skipper would order portraits from the same Neapolitan painter as his brother commanding a brigantine loading olive-oil and hang them in his cottage with the same pride.

The cutter rig was at first popular for trawlers, but was rapidly replaced by the ketch rig, just as it was in the trading vessels in the eighteen sixties, while the inshore beachmen and some fishermen in the Scottish and Cornish fishing area remained faithful to the lug sail. The ketch rig was eventually adopted for both driftnet fishing as well as trawling. Only very rarely were the luggers recorded on canvas, for their owners lived too near the subsistence level for such extravagances. The occasional bonanzas that fishing for a living brought, encouraged the production of portraits of bigger fishing vessels and the tradition lived on until almost yesterday in the major centres of the industry.

The fishing fleets working their way out to the grounds must often have passed the fleets of colliers on their way to the London River, or the South Coast ports, which continued to maintain a motley fleet of sailing vessels in the trade when they had been replaced elsewhere. Many of these were brigantines which had only been relegated to the work after being displaced by steam from more lucrative trades.

Until replaced by the internal combustion engine, both on shore and afloat, our estuaries and tidal rivers were each and every one enhanced with a fascinating variety of small commercial sailing craft. The largest of these entered the same area of trade as the sea-going ketches and schooners; the smallest loaded less than twenty tons and rarely ventured beyond the limits set by a day's sail in the hours of daylight. All were conditioned by working in waters where a primary factor of navigation, however prescribed its limits, was the tide and by the fact that their crews rarely exceeded the maximum of two men and a boy. But in hull-form and sail-plan they presented a delightful variety and here three distinct, and one related type are illustrated, drawn from the two score or so that existed, many until relatively recently. Their owners' profits were modest and their crews' wages little above those of a labourer so it is difficult to find examples of portraits of their craft. But many were family concerns and engendered a family pride, so occasionally a picture of one has survived, still treasured by descendants who are now far from the sea.

The most favoured had always been those small craft which, well found and fast sailers, played the part of a water-borne carrier's cart, plying between major and minor ports. The Pool of London, with its concentration of ancient Legal Quays with picturesque names, saw scores of little craft discharging and loading. It was a well paid trade, but sailing ships manned with the keenest of skippers and provided with the most generously equipped sail locker were powerless against calms and could be crippled by head winds. These hoy boats, as they were known, were replaced by small steam vessels long before power seriously challenged the existence of other sailing craft. The profits that might be earned by even a very modest steamship, with its high overheads, made such a venture a worthwhile proposition. It was not until much later that the marine diesel was developed which could be installed in low tonnage wooden vessels, cheaply and easily and so bring to an end the days of sail.

We conclude our brief history with the three steamers, not the transatlantic liners, who like the clippers in their time attracted a different kind of ship-portraitist, but relatively modest vessels which, with all truth, could be described as "shuttles in the Empire's loom". In them the coal went and the cotton came, the grain was shipped from Canada and the wool bales loaded at Melbourne. They

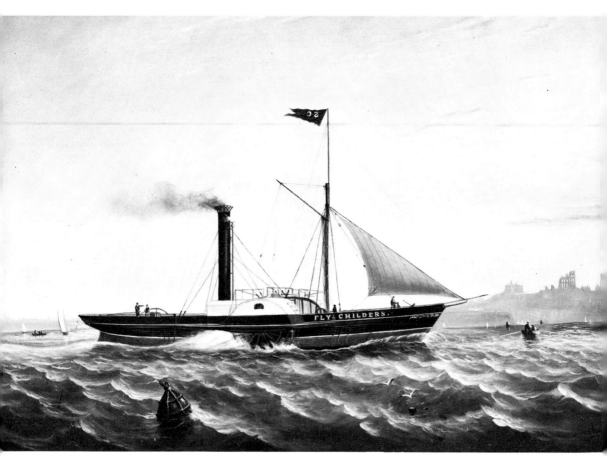

*John Scott*                    *Oil on canvas*                    *20 x 30 ins.*

'*Flying Childers* off Tynemouth'. The Tyne saw the birth of the paddle tug and they were in constant demand to handle the fleets of sailing colliers and two the keels and wherries on the river. The *Flying Childers* was built at North Shields in 1857 and was tiller-steered. Canvas was carried to be used when keeping station out at sea and so conserve fuel.          *Omell Gallery*

retained a spread of canvas, partly from tradition, partly as a safeguard against mechanical failure, for they were all single-screw ships, and also, as their frugal owners would enjoin their captains to remember, "not to allow a good, fair wind go to waste". When even these modest sails were gone it is time for us, too, to finish our story.

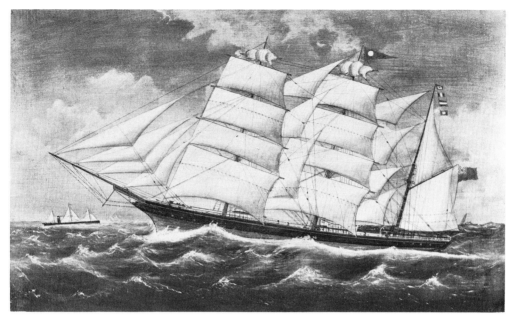

*W. L. Alfred*                    *Oil on canvas*

'*Craigmullen* Liverpool 1882'. Built of steel at Liverpool in 1875 and of 761 tons, the *Craigmullen* traded to the remoter ports of the Colonial Empire with general cargoes and building materials for roads and railways. She was owned by W. Taylor of Liverpool and flies his House Flag.                    *Simon Carter Gallery*

*H. Percival*          *Water-colour on board*          *18 x 23 ins.*

*Deva* of Liverpool. Although launched as a ship in 1873 by Thomas Royden and Sons of Liverpool, builders of many fine sailing vessels, she became a barque in 1880 on passing to William Just and Co. Like the *Craigmullen*, she sailed the world over with railway iron, cement, food grains and timber. As was the case with many of her contemporaries she came under the Italian flag in 1898 and was renamed, with come insensitivity, *Checco*, and became a hulk in 1915.                    *Author*

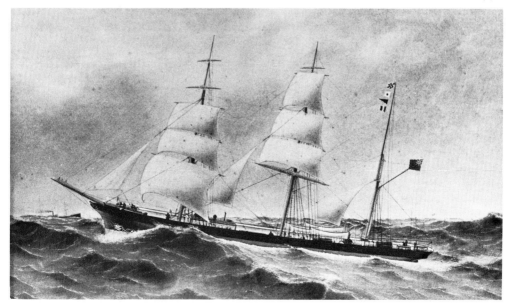

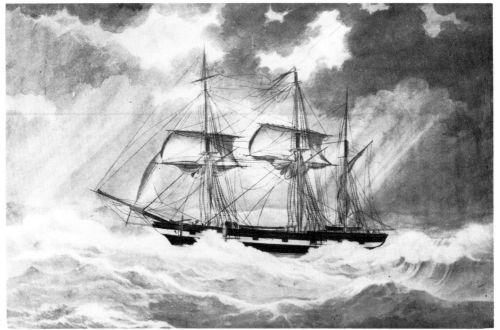

*Niccolo Cammillieri*          *Water colour on paper*          *17 x 22½ ins.*

'Bk. *Courier* of Ipswich John Elwood Master Lat 42   42   N Long 15   9' N 1846 May 19th'. Cammillieri must have welcomed the opportunity to produce a painting of such a dramatic incident as the destruction of a topgallant mast by lightning in gale conditions at sea. The style and treatment in the painting closely resembles the votive pictures that the artist produced.

*Ipswich Borough Council*

*Anon. (French)*          *Water colour on paper*          *15 x 22 ins.*

'Rescue of the crew of the *Alice* of Bath'. The Ipswich-owned barque *Faithful* stood by the American ship for four days in 1860 during a Channel gale, rescuing the entire crew, one by one, as the weather permitted. They were landed at Cowes and the crew of the British vessel received medals commemorating their efforts from President Lincoln.          *Ipswich Borough Council*

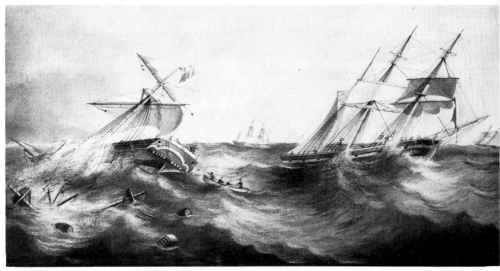

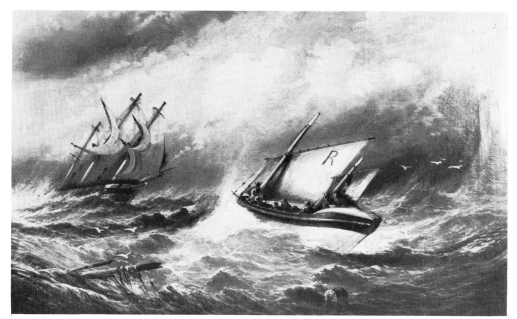

*William Broome*                    *Oil on canvas*                    *16½ x 23½ ins.*

Ramsgate lifeboat *Northumberland*. The work of the lifeboats and their crews was a favourite subject for painters of widely differing skills. Here the French barque *Eleinore*, ashore on the Goodwin Sands, is shown being approached by the Ramsgate boat; the painting is dated 1861 and it is said Broome accompanied the lifeboat on some of its rescues.                    *W. Lapthorne*

*J. Fannen*                    *Oil on board*

Ketch-barge *Genesta*. Caught in a severe gale on passage between Snape in Suffolk and Dublin, loaded with barley, in 1891 the *Genesta* broke her main boom. She was towed into Penzance, refitted and completed the voyage.                    *Hervey Benham*

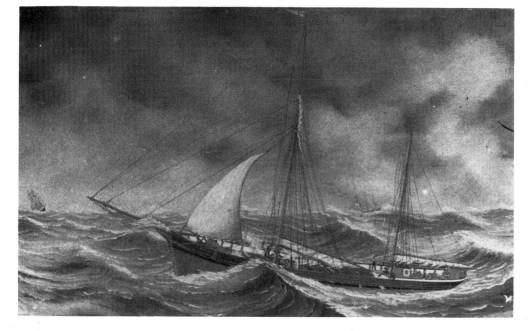

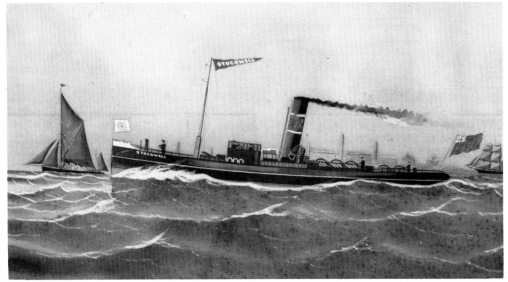

*H. May*                 *Water colour on board*             *15 x 20 ins.*

'Steam tug *Stockwell* 1894'. A typical London river tug, the foremast and funnel arranged for lowering to permit work above bridges. The painter has firmly located the scene by including a stackie-barge loaded with hay in the background.          *Robert Malster*

*Anon. (British)*                *Water colour on paper*

*Rozelle* of Glasgow. An example of a painting made directly from the drawing of the vessel's sail-plan, probably by a shipyard draughtsman. The long poop, reaching forward of the mizzen mast and the large skylight indicate that the *Rozelle* was provided with passenger accommodation. She was built at Port Glasgow of iron in 1868, 1286 reg. tons.

*Merseyside County Museums*

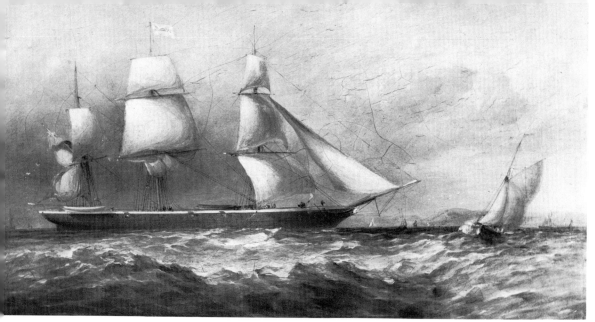

*James Harris*                 *Oil on canvas*                  *12 x 18 ins.*

Unknown ship. Possibly an early iron vessel of 1860, the House Flag at the main has proved impossible to identify. The royal yards have been temporarily sent down.      *Hugh Moffat*

*Anon. (Chinese)*                *Oil on linen*

*Elizabeth Nicholson.* Built 1863 at Annan by Nicholson, 904 tons, first voyage to Australia.
                                              *Merseyside County Museums*

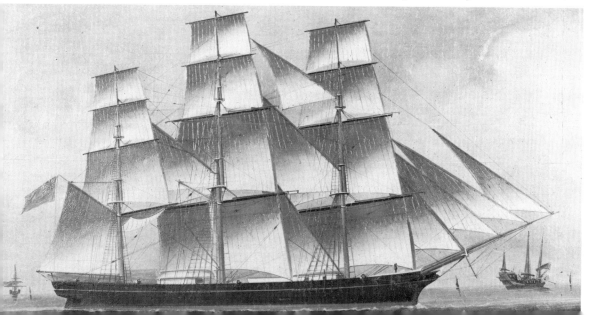

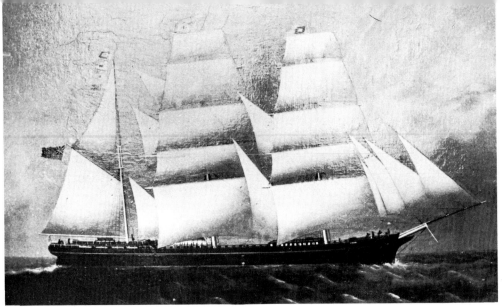

*Vanora.* This barque was launched at Sunderland by John Crown and Sons for Lumsden Byers of the same port. She traded to China and on one of these voyages this painting was purchased. Both this and the picture of the *Elizabeth Nicholson* are typical of Oriental artists' work. Chinese painters rapidly learnt the more obvious points of European style and their delicate touch was particularly appropriate for the careful delineation of the rigging. Much of their work was produced on linen which lends itself to delicate workmanship with a brush.

      The *Vanora* was sold in 1893 to South American owners and was finally registered in Peru, to be broken up in 1923.        *Sunderland Museum, Tyne and Wear County*

Sloop *Thomas.* A rare portrait of a trading sloop which can be identified as the *Thomas*, built by Thomas Griffith at Pwllheli in 1849 and owned at Nevin. The smaller view shows her with a square sail and flying topsail set, while the peculiar lead of the outer-jib halliyard is to take the strain from the slender topmast. The single member of the crew, standing forward, must have had an unenviable job handling the jib sheets when going about with such an enormous spread of head-sail canvas.        *National Museum of Wales*

*J. Fannen*            *Oil on canvas*

*Eliza* 1891. The ketch rig divided up the huge mainsail of the smack and made it more manageable. The *Eliza* was built at Southampton in 1866, but was trading to Sunderland for coal and owned at Banff when this painting was made. Of 64 tons, she was only slightly larger than the smack *Clyde*. The square-sail yard, which most ketches carried, was kept aloft in some vessels as is shown in the painting, in others it would be stowed along the main hatch until required.            *Simon Carter Gallery*

*A. K. Branden*            *Oil on canvas*

Smack *Clyde*. This 60-ton vessel must have been one of the last trading smacks built in Scotland and was launched in 1866 at Glasgow by Connell, who used oak on iron frames for the hull. She was owned at Padstow. The yacht-like round counter-stern is unlike that of the older smacks and sloops but this is the only way in which she differs greatly from her predecessors.

           *Simon Carter Gallery*

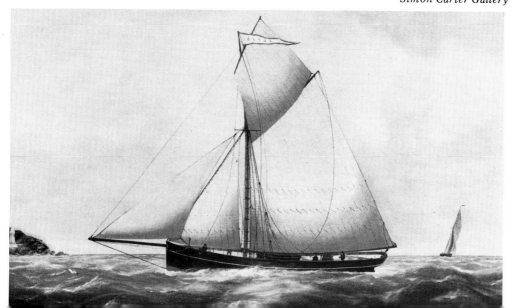

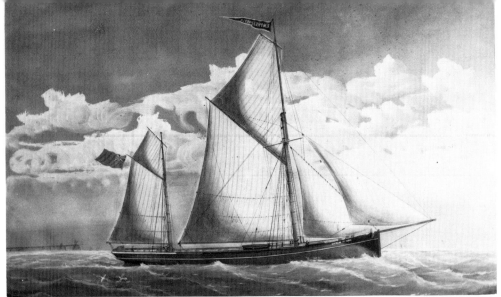

*Anon. (British)*                       *Gouache on paper*                    *24 x 40 ins.*

'*Empress of India*'. A ketch barge, although whether to flatter or through forgetfulness the painter has omitted the lee-boards which all flat-bottomed craft must carry. The *Empress of India* well illustrates the ketch rig of the time although the bowsprit, which could be steeved upright to save trouble when in crowded docks, was fixed in many West Country craft.

*Nottage Institute*

*Anon. (British)*                       *Gouache on board*                    *19 x 24 ins.*

'*Record Reign* of Maldon'. Many East Coast ketch-barges carried square topsails when they were first launched, perpetuating a much older version of the rig. This vessel was built at Maldon by J. Howard in 1897 and could load some 275 tons of cargo. She became a 'Q' ship in the First World War and was fitted with auxiliary engines but survived only to be lost by running ashore in thick fog in 1935, near Beer in Devon.                   *Author*

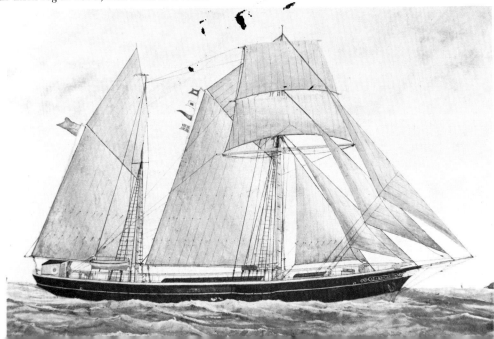

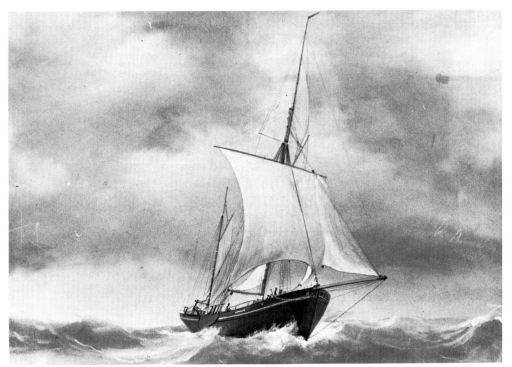

*Anon. (British)*                *Water colour on paper*                *19 x 22 ins.*

*James Bowles.* The *James Bowles*, built at Brightlingsea in 1865, spent much of her life in the coal trade. When running before the wind the ketch and schooner are both at a disadvantage for this is a bad point of sailing for a purely fore and aft rigged vessel. A square-sail was rigged, as shown in the painting, and was usually stowed on deck when not in use.    *Hervey Benham*

*John Henry Mohrmann*                *Oil on canvas*                *23½ x 39½ ins.*

*Bona.* Named from the motto of her home port of Harwich "Omnia bona bonis" the *Bona* shows the fully developed ketch rig with a standing bowsprit and roller-reefing on the mainsail. This was both quicker to use and simpler than the older system of point reefing, but it could spoil the shape of a well-cut sail and should it fail a dangerous situation could arise.

*M. Garnham*

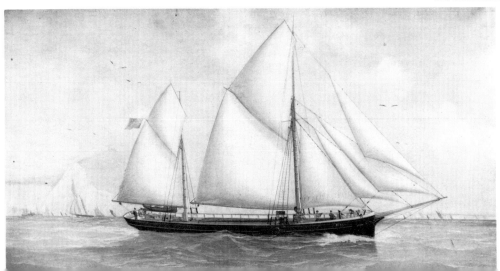

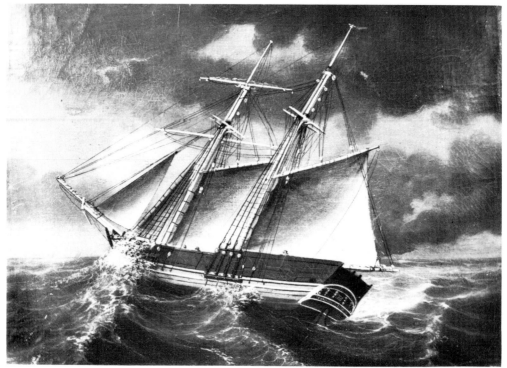

*Anon. (Antwerp?)*           *Oil on canvas*          *15 x 20 ins.*

*'Compass'*. An early example of the schooner rig and showing clearly the heavy hull-form of an early nineteenth century vessel. Built in 1823 at Ipswich, she was lengthened by twelve feet in 1850 and lost with all hands on the Cross Sands fourteen years later.    *Ipswich Borough Council*

*Anon. (British)*          *Oil on canvas*          *19 x 29 ins.*

*'Pride of Mistley* of Harwich John Mann Master May 18 1866'. The schooner is shown off Flamborough Head in the year of her launch, probably bound up with coal for her home port. The delightful painting is extremely detailed and from the insurance society flag on the foremast to the cook making his way carefully aft from the galley with a duff, nothing is omitted.

*Ipswich Borough Council*

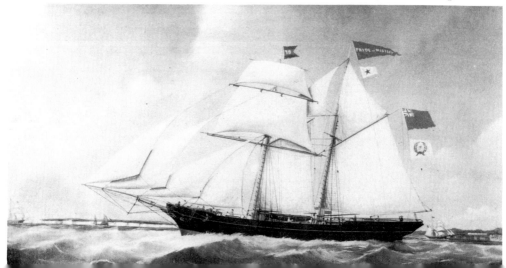

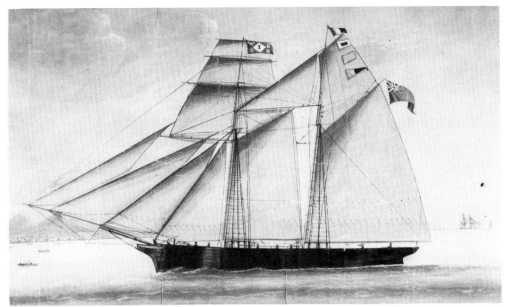

*Anon. (Neopolitan)*                    *Gouache on paper*                    *18 x 26 ins.*

'*James R. Bayley*'. Topsail schooners were ousting brigs from the Mediterranean trade by the time the subject of this painting was built in 1863 at Ipswich by W. Bayley. No doubt due to the shallow river on which her home port lay, her draught was noticeably less than that of her South and West Coast competitors. The House Flag of her owners flies at the foremast head and is equipped to set stunsails. The schooner was lost off Beaumaris in 1873.

*Mrs A. Dalby*

*Anon. (Neapolitan)*                    *Gouache on paper*                    *19 x 28 ins.*

'*Edith Eleanor*'. Built and owned at Aberystwyth in 1881, of 96 reg. tons, she was unusual amongst the Cardigan Bay schooners in setting a double topsail and flying topgallant. The double-topsail made reefing simpler and saved wear and tear on men as well as canvas. In eleven months in the eighteen nineties she made a round voyage of 11,650 miles; after leaving Portmadoc with slates she visited Hamburg, Cadiz, Labrador, Naples and finally France before sailing a final leg home to Wales.                    *National Museum of Wales*

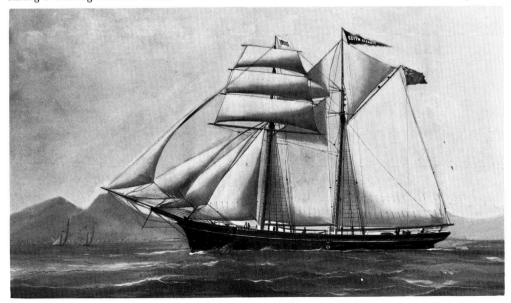

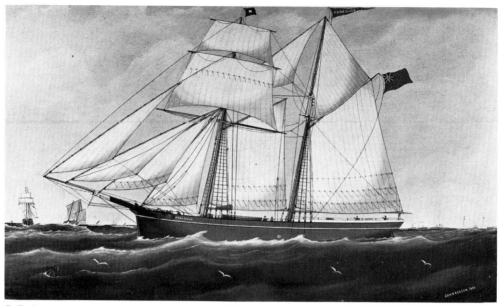

*J. Robson*                                    *Oil on canvas*

'*Anna Dixon* 1880'. Built in 1842 at Liverpool the profile of this schooner makes an interesting contrast to that of the *Edith Eleanor*. Although of very similar dimensions, the fuller lines of the older *Anna Dixon* are indicated by her tonnage of 162. She was owned at Southampton in 1880 and the painter has made sure to include the Plimsoll mark and navigational light boards which had only recently been introduced at that date.                    *Simon Carter Gallery*

*Nicola Cammillieri*              *Water colour*              *18½ x 23 ins.*

'Schooner *Essex Lass* of Colchester, John Jones Master entering Port of Malta 1844'. This schooner was unusual for, reversing the usual trend, when her foreign trading days were over, she was re-rigged as a brig and entered the coasting trade.                    *Hervey Benham*

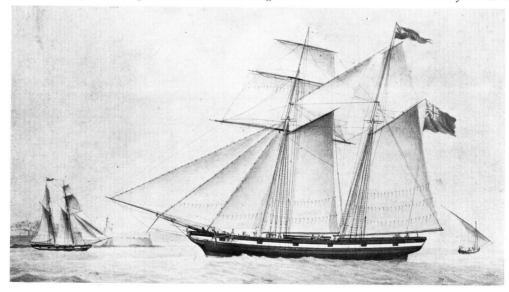

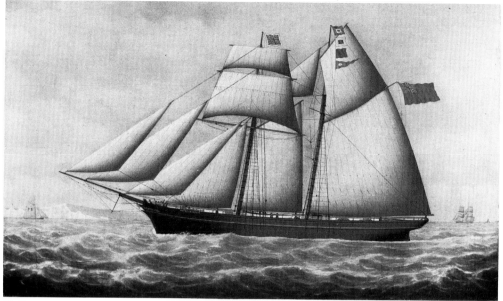

*H. Loos*                                     *Oil on canvas*

'Perseverance'. A topsail schooner built by Nickles, Port Mellon, Cornwall, for William Smith & Co. in 1874. She was considered one of the fastest of the West Country fleet. The pleasing round counter-stern marks her out as a Cornish schooner and the tiller projecting over the after skylight is also typical.         *Simon Carter Gallery*

*Samuel Walters*                                *Oil on canvas*

'Mersey pilot sloop No. 6'. This characterful little vessel may be dated to approximately 1830 and Walters has shown considerable skill in indicating the pilots on deck awaiting an incoming vessel. The pole mast, with its ample shrouds and runners, and chain jib-halliards indicate a vessel rigged to withstand heavy weather. She is almost certainly the *Irlam* built in 1831, sold out of the service in 1852, and like her companions painted yellow when a pilot sloop.         *Merseyside County Museums*

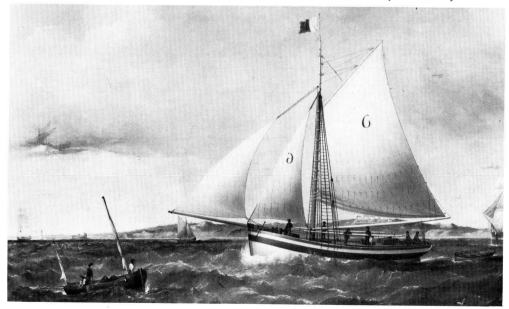

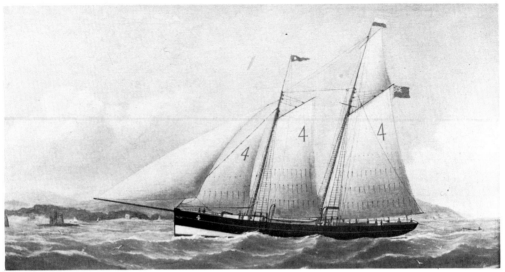

*J. Whitham*                    *Oil on canvas*                    *18 x 27 ins.*

*Mersey pilot schooner* No. 4. The pilot service on the Mersey was established in 1766 and sloops used to wait at Almwch to board approaching ships. Schooners were adopted about 1850, of which this is a later splendid example. Many were ordered from yacht builders and designers. In very severe conditions, when it was impossible for a pilot to board a ship, the schooner would hoist the signal "Follow me" and leading a fleet of ships, sail and steam across the Bar. The schooner *Auspicious*, No. 4, built in 1878 and of 75 tons, sunk off the Bar L. V. in 1895.

*Merseyside County Museums*

*George Laidman*                    *Oil on board*                    *7 x 10½ ins.*

Lynn No. 1 pilot cutter 1866. Typical of the bigger Wash fishing cutters, sailing from Lynn and Boston, the pilot boat shown here was still at work when Laidman began painting. Like many other pilot cutters, when replaced by powered vessels, the Lynn pilot boats were purchased for adaptation to cruising yachts.                    *Kings Lynn Museum*

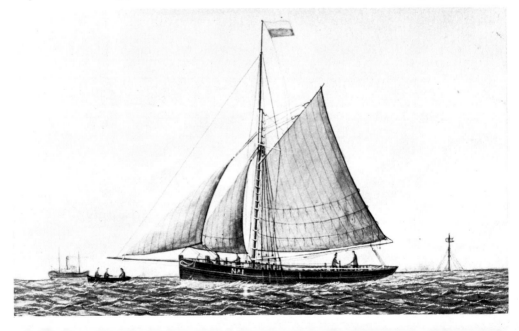

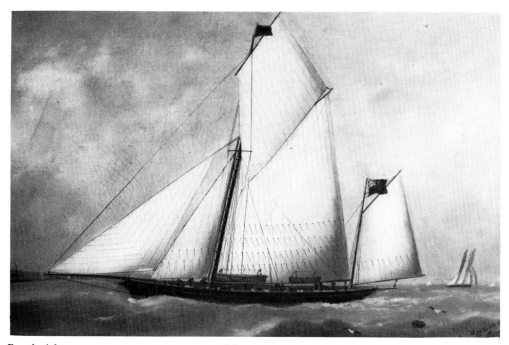

*Eoud. Adam*              *Oil on canvas*              *12 x 18 ins.*

The yawl *Jullanar*. This yacht was a yawl which, when she was launched in 1875 at Heybridge, Essex, initiated a revolution in yacht hull design. She was designed by E. H. Benhall and John Harvey and was 126 tons with an overall length of 110′ 6″. Unlike her contemporaries she was designed to ride more on the water and less in it, with a cut away fore-foot, short deep keel and long lines. After an extremely successful career, both cruising and racing, she was broken up in 1908 at Wivenhoe.                                                                 *Nottage Institute*

*Anon. (Neapolitan)*              *Gouache on paper*              *21 x 29 ins.*

Victorian schooner yacht, c. 1860. Yachts such as these, built of the finest materials and decorated internally in a land-locked Victorian taste, cruised the Mediterranean and raced in home waters.                                                                 *Nottage Institute*

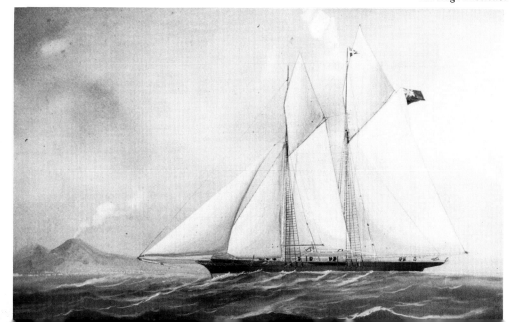

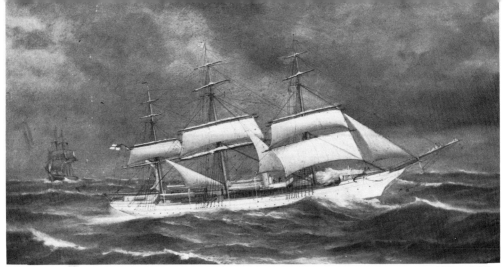

| *D. Simone* | *Oil on canvas* | *18½ x 27 ins.* |

S. Y. *Valhalla* R. Y. S. Her best-known owner was the twenty-sixth Earl of Crawford who purchased the 1,490-ton ship in 1901. She had been built in 1892 by Ramage and Ferguson as a yacht for a Mr Laycock who rigged her with stunsails and skysails, and both he and later the Earl cruised world-wide with a complement of thirty and with only occasional use of the auxiliary power. She raced in the German Emperor's Ocean Cup in 1905 and secured third prize.                                                                 *Nottage Institute*

| *R. Hord* | *Oil on canvas* | *21 x 36 ins.* |

'Brig *Thomas and Elizabeth* of Sunderland 1879'. The stumpy rig of this brig no doubt served her well enough trudging up and down the East Coast. Built in 1841 by Cuthbert Potts and Bros., North Sands, Sunderland, she traded to the Baltic. Caught in a gale on her way to the Tyne she was lost with all hands in 1880 — a fate shared by many of the colliers.

*Sunderland Museum, Tyne and Wear County*

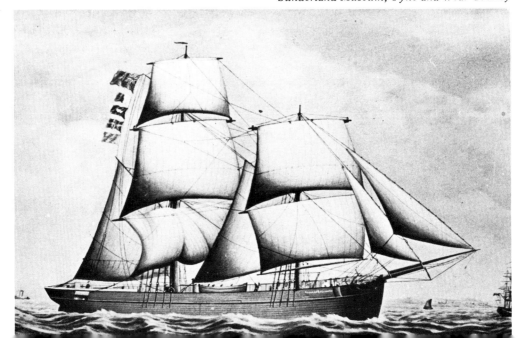

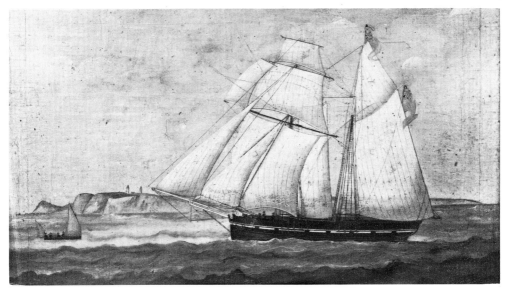

*Anon. (British)*                    *Oil on canvas*                    *20 x 27 ins.*

Schooner *Snowdrop*. Although hardly an effective advertisement for her sailmaker, the *Snowdrop*, built at Sunderland in 1851, of 112 tons, is typical of the smaller colliers. They specialised in beach-work; the captain allowed the vessel to go ashore at high-water at a convenient point and as the tide receded the cargo would be discharged into carts.    *Author*

*John Hudson*                    *Oil on canvas*                    *16½ x 24 ins.*

'*Charles Henry* of Sunderland Capt. John Anson Jan. 1860'. A brig built at Sunderland in 1823 of 223 reg. tons; she is shown with the wind on the quarter and stunsails set, although one wonders if the painter provided the main top-gallant stunsails rather than the owners.

*Sunderland Museum Tyne and Wear County*

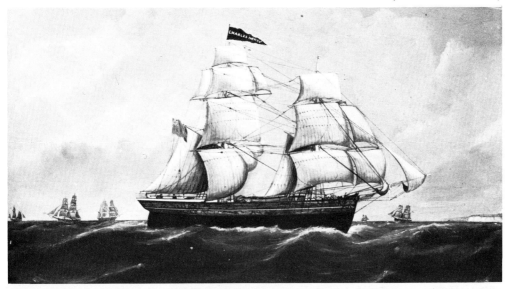

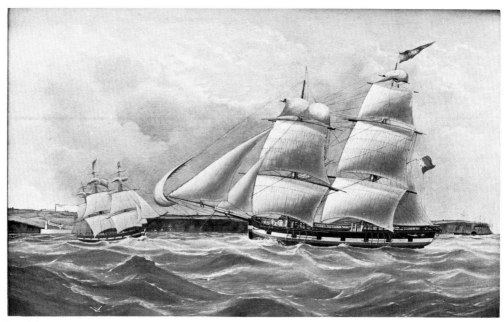

*J. Whitham*                              *Oil on canvas*

*Thomas* of Whitehaven. The coal trade from Whitehaven on the North West coast, although much smaller in scale had some similarities to that of the much older one of the North East and employed similar vessels. The huge topsails, with their three rows of reef points are typical of the period. The *Thomas* was built at Whitehaven in 1800, of 211 tons.     *Simon Carter Gallery*

*Anon. (British)*                    *Water colour on paper*                    *16 x 17 ins.*

*Earl* 1854. A very early iron screw collier built at Newcastle by C. Mitchell & Co. for the Earl of Durham. She had two cylinder engines of 70 horse power provided by a Sunderland builder. These pioneer iron colliers were the first application of powered vessels for the transportation of bulk cargoes.                    *Sunderland Museum Tyne and Wear County*

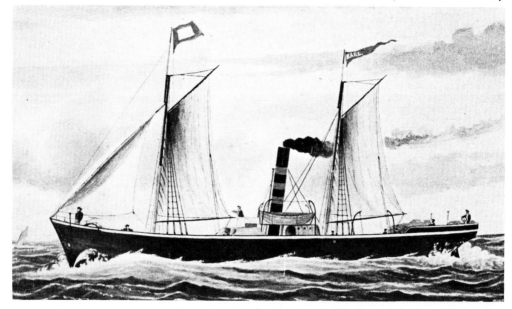

*Anon. (British)*          *Water colour on paper*          *17 x 27 ins.*

S.S. *Florence Nightingale*. An iron screw steamer with a double bottom to facilitate steaming in ballast. She was built at Sunderland for J. F. Marshall & Co. of the same port. The gaffs and booms of the fore and aft sails did duty as derricks when discharging cargo.

*Sunderland Museum, Tyne and Wear County*

*Anon. (British)*          *Water colour on paper*          *14 x 18 ins.*

R. E. 197 (c. 1880). A simple but rare sailor-painting of a fishing lugger. They were essentially large clinker-built, open boats although the South coast examples frequently added, as may be made out on the painting, a lute stern to give more space art when handling a trawl. Although more usually employed in the herring fishery, luggers were used for working a beam trawl and for long lining.          *Lowestoft Maritime Museum*

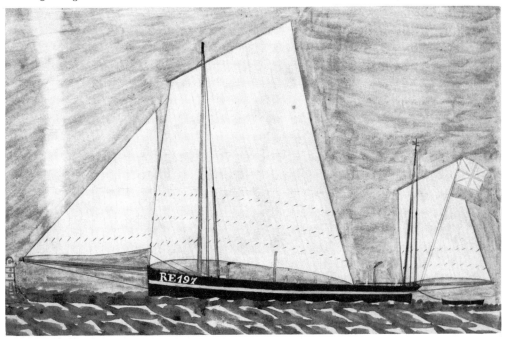

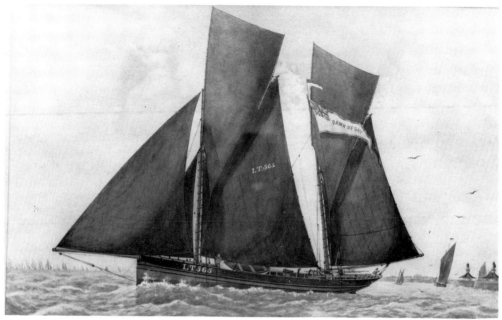

G. V. Burwood                    *Oil on canvas*                    *20 x 30 ins.*

*Dawn of Day* LT565, 1895. The final development of the sailing drifter is represented by this canvas, for the first steam drifters were being built when the *Dawn of Day* was launched. Even this enormous sail-plan could be augmented by the addition of a staysail set between the masts. An ancient method of reefing was preserved by lacing a 'bonnet' to the foot of the mizzen which could be easily removed when riding to the nets.                    *Lowestoft Maritime Museum*

G. Tench                    *Oil on board*                    *20 x 30 ins.*

*Leslie* LT 186. The less extreme rig of the trawlers is well represented by the ketch sail-plan of the *Leslie,* one of the last of the Lowestoft smacks built in 1909. The diagonal cut to the cloths of the mainsail and mizzen show an advance in sail-making and gave the canvas a better set.                    *Lowestoft Maritime Museum*

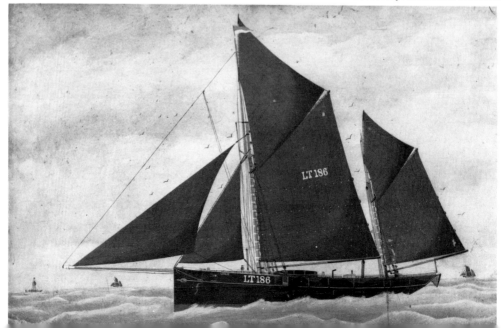

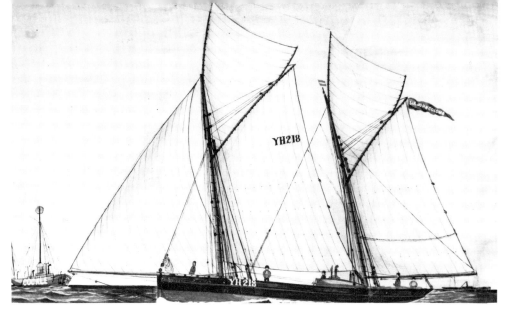

Tom Swan                    *Water colour*                    *19 x 24 ins.*

'*Sir John Colomb* YH 218 E. Layton owner'. A drifter with her summer sails set including the huge "spinnaker," fisherman's name for the large foresail, which is sheeted home aft of the mizzen. The mizzen is stayed forward by the "Tommy Hunter" and its purchase.

*Lowestoft Maritime Museum*

Tom Swan                *Water colour and ink*                *19 x 24 ins.*

*Laverock* YH 314. The *Laverock* was a wooden steam drifter built at Lowestoft by Chambers in 1901 and owned at Yarmouth by Miller. She was one of the earliest powered herring boats but at least has a wheel-house aft of the tall funnel. The very first steam-drifters did not even have this provision for the helmsman. Astern is the sailing drifter *Faith*, built in 1874, also owned by Miller.

*Norfolk Museum Services, Yarmouth Museums*

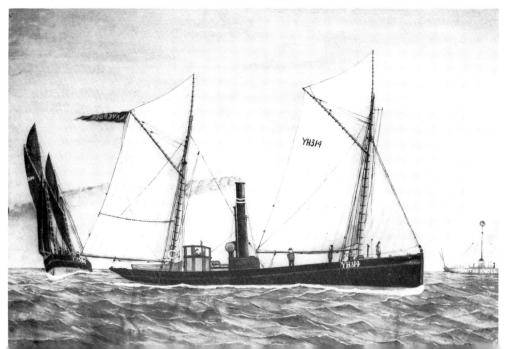

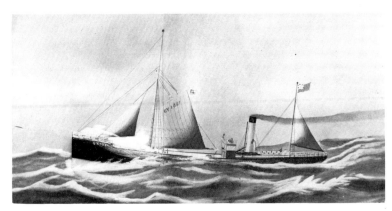

F. Ruyers           18 x 2!
*Water colour and body colour on b*

*Flamingo* GY 1021. A ketch-rigged s¹
fish carrier, built in 1885 for the C
Grimsby Ice Co. Ltd. Grimsby. T
attended the fleets of sailing tra⁻
and collected their catches which
then delivered to market either at G
sby or London. The fish-carriers b
reputation for steaming at full-sp
oblivious of danger to themselve
others, in order to deliver their car
in all weathers.

*Norfolk Museum Serv*
*Yarmouth Muse*

H. H. (of Aberdeen)     12 x 20 ins.

*Loch Lomond* A 857. A large steel-built
trawler built at her home port by Hall &
Co. in 1898. The otter-board which had
replaced the beamtrawl may be seen
suspended from the gallows just abaft
the mast.   *Lowestoft Maritime Museum*

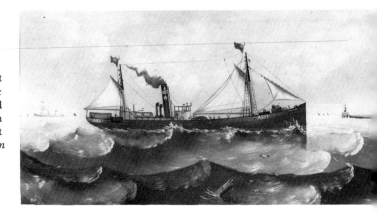

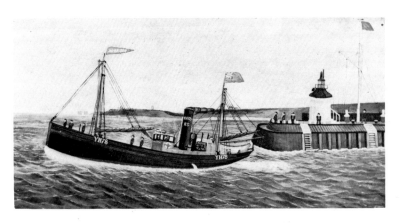

T. Swan         19 x 24
*Water colour and ink*

'*Morrison* YH 78, R. Sutton owner
lively impression of a wooden st
drifter, built at Yarmouth in 1!
leaving her home port. The *Morr*
was later owned at Peterhead.

*Norfolk Museum Serv*
*Great Yarmouth Mus*

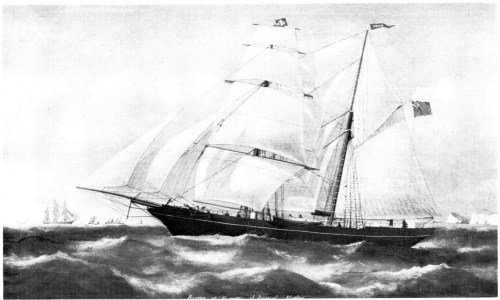

*Samuel Walters*                    *Oil on canvas*                    *16 x 24 ins.*

'*Rescue* of Guernsey J. Quiesnel Master'. Guernsey owned many fine small sailing vessels and the *Rescue* was built there in 1861 by Ogier, 207 tons and later altered in rig to a barquentine. She is shown here with Cunningham's patent self-reefing topsail, indicated by the 'bonnet' down the centre of the sail; this permitted the sail to be reefed without men going aloft.

*Simon Carter Gallery*

*H. B. Carter (?)*                    *Oil on canvas*

*Glance.* A brigantine of 129 tons built at Prince Edward Island in 1865, the *Glance* was at first owned at Teignmouth and traded to the Mediterranean.                    *Simon Carter Gallery*

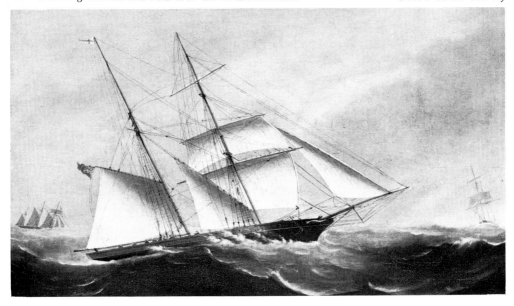

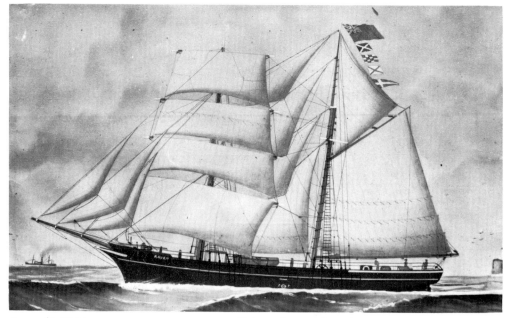

*Anon. (British)*                                   *Water colour on board*

*Raven.* The Kentish Ports, predominantly Whitstable, maintained a mixed fleet of colliers, only to be dispersed at the time of the First World War. The *Raven* built at Prince Edward Island in 1873 was one of these. Her heavy square stern was typical of many of these Canadian vessels and when first launched she would have had a royal on the foremast and a long jib-boom, later to be removed in the interests of economy.                                   *Author*

*Anon. (British)*                    *Oil on canvas*                    *26 x 40 ins.*

Four-masted barque *Holt Hill.* As steel vessels became larger, the addition of a fourth mast to the traditional ship-rig was made and by the eighteen eighties the four-masted barque became the accepted rig of the last great carriers under sail, many of them over two thousand tons. The *Holt Hill* was built by Russel in 1884 and was one of William Price's Liverpool-owned 'Hills'. The cat-walk, allowing communication fore and aft when the decks were awash, can clearly be seen in the painting.                                   *Merseyside County Museums*

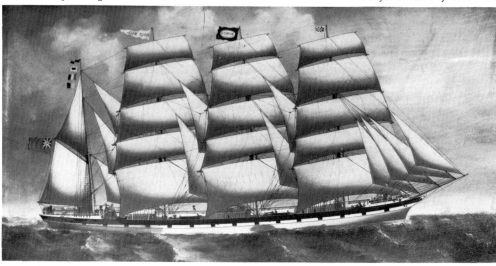

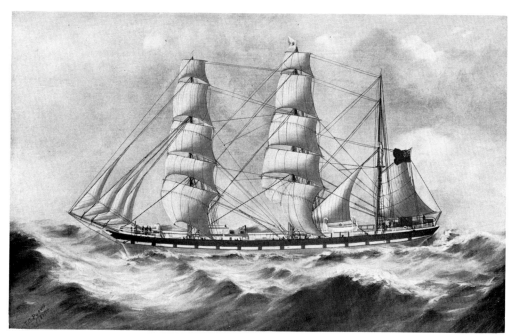

*T. G. Purvis*                    *Oil on canvas*                    *18 x 29 ins.*

Unidentified three-masted barque. A much smaller vessel than the *Holt Hill*, she dates from the same period and like the much larger four-master has painted ports. This was a feature which survived the efforts at economy by owners until the last days of sail.          *Simon Carter Gallery*

*Anon. (British)*                    *Oil on canvas*

Four-masted barque *Principality*. Owned by the Welsh County Line of W. Thomas & Co., this relatively small four-master of 1,699 tons was built at Sunderland in 1885 by Doxford. She was considered the fastest of the fleet of numerous big iron and steel square-riggers. She was lost on passage loaded with nitrates from Junin to Rotterdam in 1905 — a very bad year for those making the Cape Horn passage.          *National Museum of Wales*

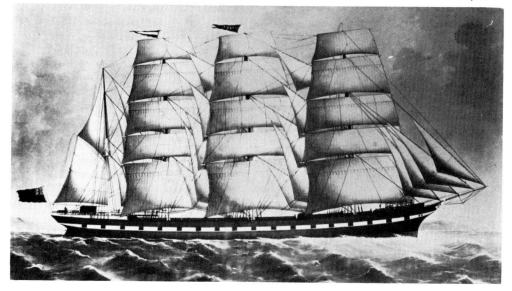

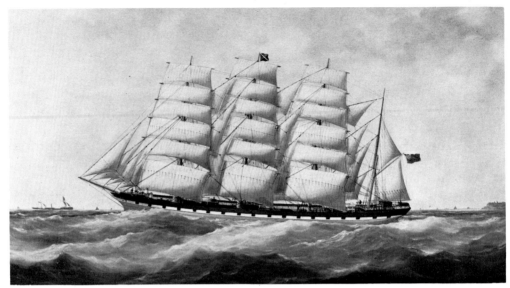

*Anon. (British)*                                  *Oil on canvas*

Four-masted barque *Cedarbank*, She represents the final development in the sailing ship's rig, with the top-gallants as well as the topsails divided into uppers and lowers. By this date skysails as well as stunsails had been discarded as unworthy of their expense. The *Cedarbank* was not, however, fitted with the mechanical aids to sail and spar handling used aboard some of the last of the windjammers. Nevertheless, the steam donkey engine boiler may be seen above the forward deck-house; this was used for cargo handling and occasionally for hoisting yards and ground tackle. She was posted missing bound for Aorhus from Halifax, N.S. in 1917.

*Simon Carter Gallery*

*W. Preston*                          *Oil on board*                          *17 x 21 ins.*

Norfolk Wherry. This painting originated in the house of a former Norwich coal merchant and wherry owner; it may represent a wherry he owned. She is typical of the smaller trading wherry, loading about 30 tons. She is shown sailing light and the artist has correctly depicted the 'down-at-the-head' look of an unladen wherry. The curious flag at the masthead in place of the normal vane is a departure from the usual custom of the Broads black-sailed traders.     *Robert Malster*

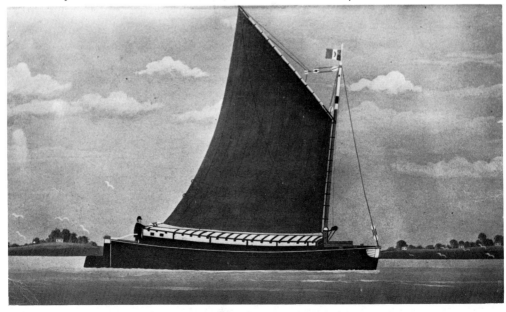

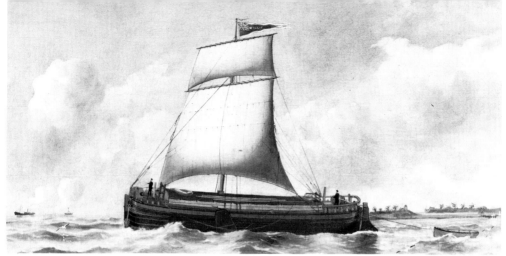

*Reuben Chappell*         *Oil on canvas*         *21 x 35 ins.*

'*Willie* of Driffield Capt. W. Verity'. The Humber sloop and keel captains were amongst Chappell's first patrons. Both the shape of the keel's hull and her simple square sail plan preserve some of the features of a medieval vessel, but the lee-boards were an eighteenth century innovation. These antique craft worked about the Humber estuary and far inland to Sheffield and Driffield. When working the canals it was necessary to lower the mast, in these circumstances the uncomplicated gear of the square sails simplified the operation and encouraged their survival when fore and aft sails were adopted elsewhere.      *National Maritime Museum*

*F. Ruyers*         *Water-colour and ink on board*         *13 x 19 ins.*

'*Haste Away*'. A typical spritsail barge employed in the Thames estuary, making occasional short coastwise voyages. The *Haste Away* was built for Edward Haste at Harwich in 1886. The bowsprit was arranged to lift upwards for sailing in constricted waters and the outer-jib, referred to by bargemen as a spinnaker or staysail, was then set up to the stem-head. After a long career in general barge work carrying wheat and fertilisers, the *Haste Away* was sold to be employed as a ballast carrier and finally, after use as a mine-spotting hulk during the Second World War, a house-boat. It was a career which, with only minor differences, was shared by many spritties.

*Jack Haste*

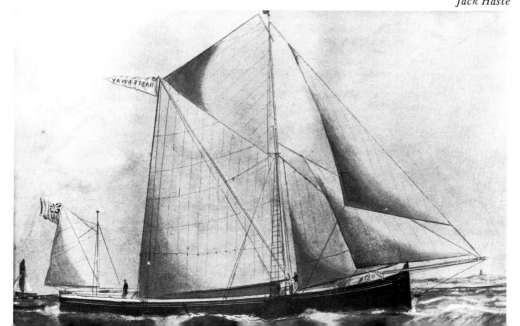

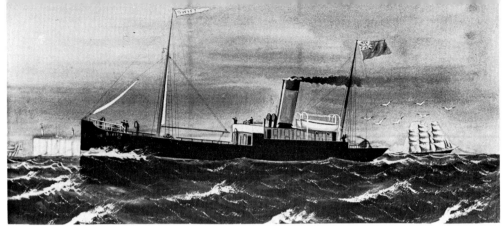

| C. C. Hyatt | Water colour | 13½ x 19 ins. |

'*Swift* 1906'. Built at Wallsend in 1886 of steel, the *Swift* spent much of her life as a passage-boat, owned by R. & W. Paul of Ipswich. She sailed from the Upper Pool to Ipswich and Lynn with general cargoes of hardware and groceries, maintaining a schedule impossible for sailing vessels and so justifying her expense.

    The arrangements for towing on her stern were fitted to enable her owners' instructions to her skipper to be carried out, to the effect that he should assist any of their sailing craft should the occasion arise. *Jack Haste*

| *Reuben Chappell* | *Water-colour* | 13 x 19 ins. |

'*Mazeppa* of Harwich Capt. W. Ward'. The hard-chined, flat-bottomed barge, because of its low cost of construction and shallow draught, was developed in the mid-nineteenth century into a short-sea trading vessel. The *Mazeppa* was a fine example of a ketch-barge, or "boomie" as they were known, and was launched in 1887 by H. Cann at Harwich. She loaded about 150 tons of cargo and had a reputation which her cargo book bears out for fast passages. It is interesting to note from her painting that as the ketch-barge developed, her mizzen became a larger sail while the main was reduced proportionately to a more manageable size. *A. D. Ward*

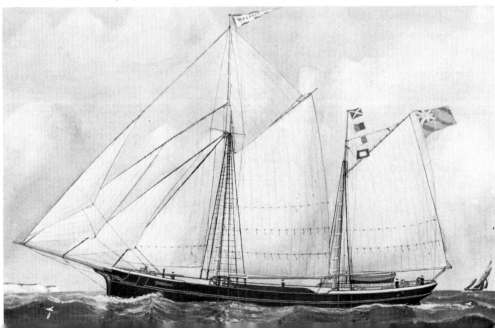

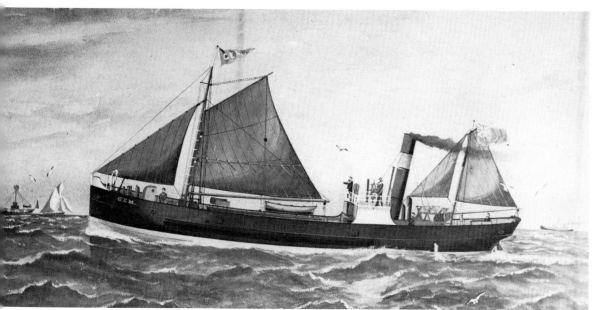

*S. H. Kiltoe*          *Water colour on paper*          *18 x 24 ins.*

'S.S. *Gem* 1902'. The little steam-hoy *Gem* was built at South Shields of iron in 1881 and registered at Colchester the same year. Only eighty feet in length and sixteen feet in beam, she loaded a modest one hundred tons. But the *Gem* worked regularly between the Upper Pool, her home port, not an easy place to reach, and Mistley with general cargo. Her ketch rig was not merely a decorative adherence to past traditions but a useful addition to the power of her very modest engine. After her hoy work was over she undertook general coasting.    *Nottage Institute*

*Anon. (Neapolitan)*          *Gouache*          *16½ x 23½ ins.*

'*Seaham Harbour*'. A West Hartlepool-built steamer launched in 1880 E. Withy & Co. for the coal trade, 1904 tons, 2 cylinder engine. She was sold to foreign buyers in 1927.

*Sunderland Museum, Tyne and Wear County*

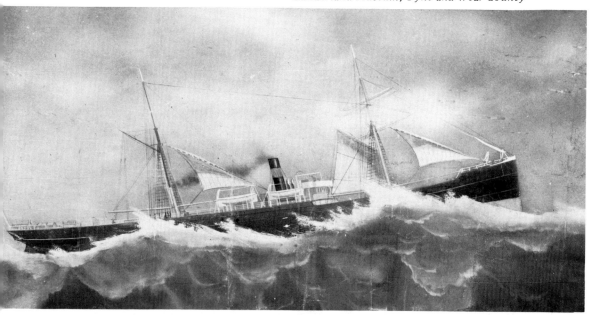

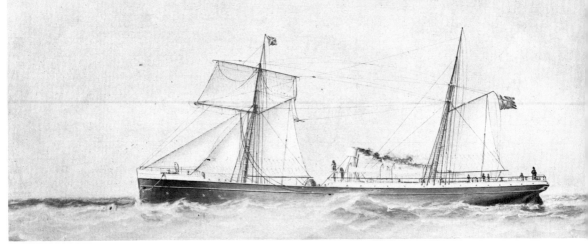

*M. McLachlan*          *Oil on canvas*

Schooner rigged steamer, not identified, c. 1865. The long poop became popular with builders at this date. Although a relatively large vessel, the helmsman is still in the traditional position at the stern and the vessel is only conned from the very rudimentary bridge.     *Peter Barton*

*Anon.*          *Gouache on paper*          *19 x 27 ins.*

'*Ruperra* of Cardiff'. She flies Cory's flag and was built at Jarrow of iron in 1883; the painting was probably made when she was taking Welsh steam coal to the coaling station at Port Said.

*J. H. Clegg*

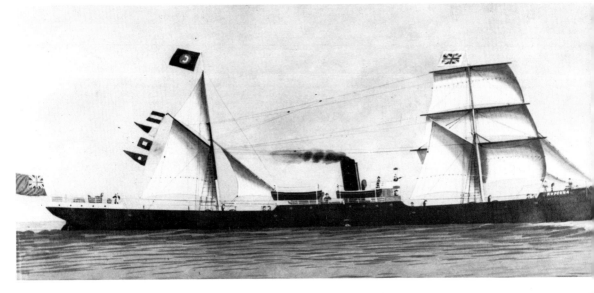

# BIOGRAPHICAL NOTES ON INDIVIDUAL SHIP—PORTRAITISTS

The list is restricted to painters known to have portrayed British registered vessels; the majority have at least one example of their work illustrated in the book.

ADAM, Edouard
(b. Brie-Conte-Robert, France 1847; d.c. 1922) Worked at Le Havre and was made official painter to the Department of the Marine in December 1885. By the time of his death he had painted a very wide range of vessels, steam, sail and yachts. His most ambitious canvases are of C.G.T. liners.

ALFRED, W. L.
(fl. 1870-90) Sunderland painter, worked in gouache, oil and water colour. His later work is very competent.

BURWARD, George V.
(c. 1855 d. 1917) Styled a "Marine Illuminator and Artist." Worked as ship-portraitist at Lowestoft specialising in sailing fishing vessels, employing a colourful but carefully contrived style. Also an expert model-maker who earned royal patronage.

CAMMILLIERI, Niccolo S.
(fl. 1835-1850) The setting of all his known paintings is Valetta Harbour so we may assume that he was a Maltese artist. Examples of his 'votive' work exist in churches. Unlike the majority of Mediterranean ship-portraitists he did not use gouache alone but employed it in conjunction with transparent water colour and an ink line to produce a fresh and animated effect.

CHAPPELL, Reuben
(b. Hook, nr. Goole 1870; d. 1940 Cornwall) Apprenticed to photographer, self-taught artist. Supporting himself by ship-portraiture by the time he was twenty. Worked in oils and to some extent in gouache, but his major output was in water colour. Moved from Yorkshire to Par in Cornwall in 1904, but continued to sign himself "R. Chappell Goole"; work rarely dated. Name of vessel, port or registration and sometimes name of captain informally lettered at bottom of painting.

CLARK, William
(b. Greenock 1800 — d. 1870) A Scottish marine artist, born at Greenock he remained in his native town working from a studio in William Street and found commissions from, amongst others, the early steam-ship owners of the Clyde. His romantic style usually has a Clyde setting.

COLLINS, H.
(fl. 1800-35) One of the group of Whitehaven marine painters who probably stem from the influence of Henry Nutter (1758-1808). His work usually includes a view of Whitehaven.

CONDY, Nicholas
(b. Plymouth 1816 — d. 1851) An artist who specialised in portraying the yachts and

yacht-racing of the mid-Victorian period. Educated at Exeter, Condy displayed an early talent for drawing and at the age of thirteen sold a sketch to the Earl of Egremont of the Earl's yacht *Kestrel* for ten guineas. Encouraged by his father, also a marine painter, he established himself at Plymouth and was never short of patronage. Unfortunately an early death at the age of thirty-five cut short a promising career. His style is sophisticated and perpetuates a fashionable romanticism.

### DUNN, Lawson

(fl. 1810-40) Described by a contemporary as painting in "a very superior style" he was a Stockton artist who produced portraits of early Teeside-built sailing ships. They include the *Tottenham* (1802) and West Indiamen *Rosalind* and *Miranda*.

### DUTTON, Thomas G.

(b. 1820 — d. Clapham 1891) Began as a lithographer reproducing work of others. Produced lithographs from his own drawings and water colours from about 1850 onwards. He achieved a great variety of interpretation and treatment within the limitations of conventional ship-portraiture recording merchant and naval vessels and yachts. Occasionally collaborated with others, particularly H. Fry. Signed with monogram, initials or full name.

### FANNEN, J.

(fl. 1880-1900) Sunderland artist, sometime policeman. Signed work "J. Fannen" and date, in lefthand corner of canvas. Worked in oils, painting sailing vessels of all types, but small coasters in coal-trade more frequently. North East Coast topography, Flamborough Head, Tynemouth, etc. commonly introduced into background.

### FEDI, Guiseppe

(fl. 1790-1820) Extremely gifted early Italian ship-portraitist who also contributed 'votive' paintings, worked in gouache. Originating in Ancona his later paintings indicate he was working at Leghorn on the Western coast of Italy. His sense of scale and perspective is much more professional than that of his mid-nineteenth century successors, painting in the same area.

### FILATI, Egido.

(fl. 1770-1800) An early painter of ship portraits, working in the Mediterranean tradition at Ancona. Produced 'votive' paintings as well as portraits of Northern European shipping.

### FONDA, Nicola

(fl. 1840-60) Worked in gouache, the best known of the Neapolitan ship-portraitists; usually painted vessels in profile from leeward entering Naples harbour.

### FONDO, Michele

(fl. 1850-70) Neapolitan ship-portraitist working in gouache.

### GREGORY, P.

(fl. 1890-1914) Lowestoft shipyard painter who produced many lively naive pictures of sailing and steam vessels. Used sign-writers colours and varnish on board. Usually signed himself with a monogram 'PG'.

### HANSEN, B. H.

(fl. 1827-56) One of a group of painters, specialising in ship-portraiture and working in

the first half of the nineteenth century at Altona, producing pictures of shipping using the Elbe. Another Hansen, H.C., working at the same time also at Altona, which was then a small port independent or, but close to, Hamburg. Both artists painted in oils, rather stiff and irresponsive in style but with the technical detail portrayed immaculately.

HARRIS, James (Snr.)
(1810-1887) Born Exeter 1810, settled Swansea in the 1820's with his father who worked as a picture framer and gilder. James moved to Mumbles in 1850, living at Reynoldstown, Gower. His work in oils is accurate and vigorous and his technique involved the use of impasto.

HARRIS, James (Jnr.)
(1847-c. 1915) Son of above, born Swansea 1847. Work similar to his father's but generally on smaller scale and less lively and duller in colour.

HEARD, Joseph
(b. Whitehaven 1799 — d. 1859) Active as a ship portraitist on the North East Coast, working in a powerful dramatic style.

HORD, R.
(fl. 1860-80) A vigorous, untutored painter working in Sunderland, whose lively style in oils carries the conviction of a firsthand knowledge.

JACOBSEN, Antonio
(b. Copenhagen 1850 — d. New York 1921) Received an art training at Copenhagen Academy. He emigrated to New York from Denmark in 1871. An employee of the Old Dominion Line admired his work and persuaded him to embark upon ship-portraiture, which he did with considerable success; mainly portrayed steamers of the days of the flourishing transatlantic service.

KNELL, William A.
( — d. London 1875) One of three painters of this name, but probably the best known. A prolific artist whose range was considerable and exhibited at the Royal Academy. He painted carefully drawn ship-portraits in both oil and water colour and pastiches of eighteenth century marine pictures in a rather heavy-handed style.

LAIDMAN, George
(b. Kings Lynn 1872 — d. Kings Lynn 1954) Served as seaman and mate in coastal vessels, then entered Customs and Excise as a Water-Guard officer. Painted between 1903-40 as semi-professional ship-portraitist, working in water colours and oils. Picture on very small scale but meticulous in detail. Painted every type of vessel besides generalised seascapes with shipping.

LAMAETINIERE, Alexander.
(fl. 1840-60) Glass-painter working at Dunkirk, probably of Flemish origin.

LOOS, H.
(fl. 1840-70) Considered by his native city to be a semi-professional painter, working in oil. Signed paintings "H. Loos L'Anvers" so he must be placed at Antwerp; this is confirmed by the inclusion of a view of Flushing in many of his canvases.

THE SHIP PAINTERS

LOOS, J. H.
(fl. 1860-80) Possibly a son of H. Loos. His style is less stylised than that of the latter but he has the same ease of command over the technical details of a sailing-vessel.

LUCK, Kenneth
(fl. 1910-26) Unusual in working from photographs taken by his partner in a photography business at Gorleston, near Great Yarmouth. No known portraits of any ships but fishing vessels,

LUSCOMBE, Henry A.
(fl. 1845-1865) A professional painter who exhibited at the Royal Academy and appears to have been centred on Plymouth. His work included portraits of the early steam vessels and his style is identifiable by his liking for dramatic conditions and naval engagements.

LUZZO, Vincenzo
(fl. 1855-73) Produced numerous ship-paintings and some 'votive' pictures in water-colour.

MacFARLANE, D.
(fl. 1850-70) A Liverpool painter working in oils and portraying sail and steam in a rather pedestrian but painstaking style.

McLACHLAN, M.
(fl. 1850-75) This Stockton-born artist graduated from employment as a shipyard painter to a ship-portraitist. Portrayed vessels, both steam and sail, commissioned by the Stockton shipbuilders H. F. Craggs, Harkness, Backhouse and Dixon, Blair, F. Atkinson and others, painting from working drawings of the ships.

MEARS, George
(fl. 1870-95) A prominent portrayer of the Railway Steamers of the South Coast ports; marine painter to the L.B. and S.C. Railway. His rather smooth style combined with an acceptably conventional naturalistic rendering of sea and sky made him popular with the late Victorian yacht owners.

MOHRMANN, John Henry
(b. San Francisco 1857 — d. Canada 1916) Of German emigrant parents. He went to sea at an early age, only gradually found a career in painting ship-portraits, picture restorer in England c. 1880. Settled Antwerp 1890, although ship paintings date as early as 1881. Output after 1890 prolific; a typical painting is in oils on a large scale and he depicted a wide range of vessels, both sail and steam. Emigrated to Canada 1913.

PAULSON, E.
(fl. 1840-65) One of the earlier of the numerous Sunderland ship-portraitists. He worked in oils, with a fine bravura. Although his technique at rendering detail is excellent there is a lack of professionalism in the composition of his paintings.

PELLEGRIN, Honore
(fl. 1810-50) Worked in Marseilles using gouache and transparent water colour. His work is not so imaginative as that of the Roux family, of whom he is contemporary, but he commanded a pleasing naturalistic style. The topography of Marseilles harbour usually forms the background of his paintings.

PERCIVAL, H.
(fl. 1880-1910) One of the most skilful and prolific of the later London ship-portraitists. Signed work "H. Percival" and date, in pen and ink script. Unfortunately his work, like all water colours — and it was in this medium he usually painted, suffers from fading and the deterioration of the board which he used. Specialised in painting windjammers in heavy seas, under shortened sail.

PETERSEN, Jacob
(b. Flensburg 1774 d. 1855) He went to sea in the Danish Navy and rose to the rank of captain. Upon retirement he came into contact with C. W. Eckersberg, professor at the Copenhagen Academy and assisted him by advice and help on his large seascapes. He was a prolific worker, usually employing gouache, and his output is all of a high technical level. A view of Kronberg Castle, with its easily identifiable towers, is usually included in his painting.

PIKE, W.
(fl. 1830-50) Liverpool ship-portraitist, a less dashing stylist than Walters; his topographical references are childlike but his shipping is painted with precision.

PURVIS, T. G.
(fl. 1900-1914) A Cardiff ship-portraitist, possibly semi-professional. His work is rather heavy, particularly in the treatment of the rigging, but his seas have an undoubted impressiveness.

RACE, George
(b. Sheffield 1872 d. 1957) An untrained artist, he began painting fishing vessels at Grimsby, living close by at Cleethorpes. Visited Lowestoft annually from 1908 onwards, painting steam drifters and trawlers. Produced a number of 'life-buoy' framed miniatures amongst a huge output; for some time assisted by his son William. Signed his paintings "G. Race" and date, sometimes "G.R."

ROUX, Joseph Ange Antoine
(b. Marseilles 1765 d. 1835) Doyen of French ship-portraitists and his work dates from 1790 when he was also producing 'votive' paintings. Owned ship chandlery on Marseilles quayside between Fort Saint Jant and the Hotel de Ville. Numbered ship-captains of all nations amongst his patrons, but especially Americans.

ROUX, Antoine
(b. Marseilles 1790 d. 1872) Followed father in painting ship-portraits in water colours. A sensitive and accurate worker, producing paintings of naval as well as merchant vessels.

ROUX, Francois Geoffrey
(b. Marseilles 1811 d. 1882) The youngest of the Roux family and son of Joseph Ange, engaged in marine painting, who besides painting the more modest merchant vessels of all nations depicted the French navy with careful technical accuracy and a sensitive treatment of setting.

RUYERS, G. T.
(fl. 1880-1900) London ship-portraitist who worked in a combination of gouache and transparent water-colour. His works have suffered, in nearly every case, from severe fading. His technique is rather perfunctory when dealing with detail, due no doubt to an over-large output. He produced numerous paintings of Thames spritsail barges.

SALMON, Robert
(b. Whitehaven 1775 d. c.1844) Painted first at Whitehaven, where a number of marine painters worked, first known painting dated 1800. Moved 1806 to Liverpool, received patronage of the nobility. Arrived Greenock 1811 and painted ship-portraits and topographical work. After visiting London, North East coast and Southampton he left Liverpool for New York in 1818. During the years 1828-40 he lived and worked at Boston, Mass., painting ships and harbour scenes. His eyesight failing, he returned to Europe in 1842 and died soon after.

SCOTT, J.
(fl. 1857-73) A Newcastle painter in oils with a capacity for the skilful handling of detail and a competent treatment of sea and sky. Many of his pictures include topographical reference to the Tyne and North East coast.

SORVIC, Fredrick, Martin.
(b. Bergen 1820-1892) Dominates the collection of Norwegian ship portraits and depicted some British vessels. Also worked as a scene painter for the National Theatre. Most of his out-put is in gouache and of steam as well as sail, he only turned to oil in his last years. Rather robust lithographs were made of some of his paintings.

SMITH, Arthur
(fl. 1830-50) A Scottish artist whose accomplished style is in the high Romantic tradition. His talent was well employed in producing oils of the clipper ships and barques built by Alexander Hall & Sons, of Aberdeen all of which he depicted with immaculate detail. They and the other vessels he portrayed are usually shown off Girdleness, or passing the Bass Rock.

SWAN, Tom
(fl. 1890-1914) A Great Yarmouth painter whose work is restricted to depicting East Coast sailing and steam-powered fishing vessels. Quite untutored, his naive style has an especial appeal; worked in water colour reinforced with ink line.

TEUPKEN, D. A.
(Amsterdam fl. 1840-70) Worked in both oils and gouache in rather a hard style, depicting both sail and steam, prefering 'heavy weather' settings for his subjects.

WALTER, Miles
(b. 1774 d. 1849) After an apprenticeship as a shipwright, went to sea and rose to a position of command. Although he settled in London in 1805 many of his paintings are portraits of Liverpool ships and have a topography include which indicates the North East coast, e.g. the South Stack light, etc. His son Samuel assisted him in later years and some canvases are signed "Walters and son". Both were involved with a family picture-framing business.

WALTERS, Samuel
(b. at sea 1811 d. Bootle 1882) His working life spanned the great days of sail at the port of Liverpool and although he is associated with the North East he moved to London in 1845 but returned to Merseyside two years later. He maintained a family in considerable comfort from the rewards of his career as a ship-portraitist and his paintings of British and American clippers are well known. He had aspirations to paint more typically Victorian subject pictures and exhibited at the Royal Academy. His work is strongly

romantic in feeling and his success led it to be widely imitated by others during the middle decades of the nineteenth century.

WARD, John
(b. Hull 1798 d. Hull 1848) Son of a master mariner of Hull, apprenticed as a house and ship painter and worked as a sign writer. William Anderson (1757-1837) influenced him and copies of paintings exist of his work made by Ward. Ward's firsthand experience of the sea extended to the Arctic which he visited aboard a Hull whaler. His paintings are only rarely of a single ship but of subtly arranged groups of named vessels. He was an excellent draughtsman and lithographer, producing instructional books for sign writers and books of plates intended for similar purposes. These were intended for aspiring artists and show typical merchant and naval vessels.

WARD, William James Jnr.
(b. Hull 1800 d. 1840) The son of William Ward, also a Humberside marine artist. Primarily an engraver but, like his father, who influenced him strongly, he produced ship-portraits owing something to the style of Huggins.

WEYTS, Carolus Ludorvicus
(b. Ostend 1828 d. Antwerp 1876) Elder son of Petrus Weyts, assisted father in production of glass-paintings of ships; after his father's death he painted pictures in a more sophisticated, naturalistic style than Petrus, continuing to work at Antwerp. Ships in his paintings are always seen from the starboard side.

WEYTS, Ignatius J. J.
(b. 1814 Ostend d. Antwerp 1867) Brother of Petrus, probably worked in the studio of his brother producing glass-paintings. No signed pictures by him are known.

WEYTS, Petrus Cornelius
(b. Gestel 1799 d. Antwerp 1855) Born at Gistel, near Ostend; stated to be a "painter" in 1824 and his earliest works dates from this year. Moved to Antwerp 1838 where he died in 1855. Renowned for his glass-painting, but also undertook oil and water colour portraits of ships. Organised a studio where he worked in collaboration with his sons and brother. His work is colourful, but rather stiff and formalised; always added a descriptive text to his paintings.

WHITHAM, J.
(fl. 1870-90) Liverpool painter working in oils, his work shows a sophisticated style with an affinity to Samuel Walters.

WILKINSON, E. W.
(fl. 1880-91) A Sunderland artist who used the monogram E. W. on his work. Rather pedestrian style, but his rendering of technical detail cannot be faulted, usually worked in water-colour.

WILLOUGHBY, Robert
(b. Hull 1768 d. 1843) One of the numerous Hull marine-painters, he has a rather lighter touch than most of his contemporaries. He began as a semi-professional and worked originally as a sign painter. Whalers in the Arctic are amongst his better work.

YORKS, William
(fl. 1855-91) A Liverpool painter who spent much of his working life in the port as a ship-portraitist. His paintings are to be found on both sides of the Atlantic and he is well represented in public collections. His work is usually fully titled with details of place and date while the signature "W. M. Yorke, Liverpool" and date, are added separately.

# GLOSSARY

**Barque**
By the mid-nineteenth century this term was reserved to describe a sailing vessel of three or more masts, the aftermast of which was for and aft rigged (U.S. bark).

**Barquentine**
A sailing vessel of three or more masts of which only the fore-mast is square-rigged and the remainder carry only fore-and-aft sails.

**Billy Boy**
A round-sterned trading craft of small tonnage peculiar to the Humber and Wash; often clinker-built and rigged as a cutter with square topsails or as a ketch.

**Brig**
A two masted vessel, square-rigged upon each mast, distinguished from the snow (q.v.) by carrying a large fore and aft gaff mainsail on the main-mast, extended along its foot by a boom.

**Brigantine**
A name given to a two-masted rig which altered over the centuries, but was usually associated with relatively small vessels. At the beginning of the eighteenth century it referred to a two-masted rig, both masts carrying square-sails and on the after mast a large fore and aft sail, either gaff or lug. By the mid-nineteenth century it implied a vessel rigged with a foremast equipped with square sails and main-mast fore and aft rigged.

**Bulwarks**
Extensions of the vessel's hull upwards to afford protection to the deck.

**Channels**
(Chainwales). Strong broad planks projecting from the sides of the older type of wooden vessel to give greater spread to the lower rigging.

**Clipper bow**
Broadly speaking this indicated a form of bow where the line of the planking where it terminated followed the curving or forward rake of the line of the stem.

**Cutter**
Used to describe a single masted sailing vessel, fore and aft rigged, with a bowsprit and setting two or more headsails.

**Gaff**
A spar at the head of a fore and aft sail.

**Gasket**
A plaited cord fastened to the yards and used to secure a furled sail by wrapping it round. Gaskets were fitted to the centre, quarters and extremities of yards.

**Jackstay**
An iron bar, wire or rope secured along the upper forward length of a yard, or the after side of a mast, for the purpose of securing the sail.

**Jib-boom**
A spar fitted along the top of the bowsprit, projecting well beyond it and to which the outer head-stays are set up.

**Keel**
When used to indicate a vessel refers to river and estuary craft of the N.E. coast of which the most distinctive is the Humber keel. These survived until recently and were unusual in being rigged with

|  |  |
|---|---|
|  | a single mast on which was set a squaresail and topsail. |
| Ketch | Usually a small fore and aft rigged vessel; two masted which the after of the two is considerably shorter. |
| Lug-Sail | A simple fore and aft sail, secured to a yard and hoisted to leeward of the mast. It was to be found with variations in use on small vessels and boats, especially fishing craft. |
| Martingale | A wooden or iron spar projecting down from below the bowsprit cap to give a greater spread to the stays below the spar and so counteract the upward pull of the head-stays. Also known as the dolphin-striker. |
| Peak | The upper outer corner of a gaffsail. Also used to describe the outer end of the gaff; thus a flag hoisted to a block on the end of the gaff is said to be at the peak. |
| Quarters | That part of the ship's side between the mizzen rigging and the stern. Hence 'quarter windows', windows at this point of the hull illuminating stern cabins. |
| Ratlinse (or Ratlins) | Short lines worked across the shrouds at convenient intervals to provide a rope ladder for men going aloft. |
| Reef Points | Short lengths of rope hanging on each side of a sail by the tying together of which it is reduced in area. |
| Schooner | A fore-and-aft rigged vessel of two or more masts. In British waters this term was commonly used to describe such a vessel although some square sails might be carried on the fore mast. |
| Ship | Strictly a word reserved to indicate a sailing vessel of three or more masts, square rigged on each mast. |
| Skysail | The topmost of the squaresails normally carried and then only rarely, the sail above the royal. |
| Snow | A two-masted vessel which emerged c. 1730, square-rigged on both masts and with a trysail mast fitted directly abaft the main. On this was set a fore and aft sail from a gaff, but without a boom to extend the foot. |
| Spike Bowsprit | A single spar combining bowsprit and jib-boom, also known as horn-bowsprit. |
| Square-Sails | A term given to all sails carried on yards running across the vessel, as distinct from fore and aft sails which are carried on spars in line with the keel. An especial use of the term was to describe the temporary sail carried by schooners when sailing off the wind beneath the fore-yard. |
| Stunsails | A corruption of the term 'studding sails'; light sails set outside a square sail, the head being attached to a small spar. These sails were carried from studding sail booms which were extended from the |

yard arms. Studding sails were used to increase the effective sail area when running before the wind or nearly so.

**Stanchions** Upright supports in a vessel's construction. Bulwark stanchions secure the planking of the bulwarks and are fixed to the frames of the vessel.

**Taffrail** The Stern rail.

**Topgallants** The squaresail directly above the topsails. Just as topsails were divided into upper and lowers, so were topgallants on the larger ships and barques etc. of the last decades of the nineteenth century.

**Topsails** The squaresail directly above the mainsail. In order to make their handling easier as ships became larger they were divided into upper and lower topsails or 'double topsails'. The squaresails permenently carried by schooners were known as square topsails.

**Truck** A circular piece of wood at the top of the mast and provided with a sheave for the signal halliards.

**Viol-block** A large double block, not unlike a bass-viol in shape.

*Competitor* of Ipswich, 1840                                                                    *Author*

# BIBLIOGRAPHY

These books are recommended for assisting in tracing the history of individual vessels besides enlarging upon the historical section of the present volume.

| | |
|---|---|
| BOUQUET, Michael | *South Eastern Sail,* Newton Abbot 1972.<br>*West Country Sail,* Newton Abbot 1969. |
| GREENHILL, Basil | *The Merchant Schooners* Volumes I and II, London 1951.<br>New revised edition 1968. |
| HUGHES, Henry | *Immortal Sails,* London 1946. |
| LLOYDS REGISTER | Lloyds Register of British & European Shipping, London annually since 1834. |
| LUBBOCK, Basil | *The Arctic Whalers,* Glasgow 1937.<br>*The Blackwall Frigates,* Glasgow,<br>*The China Clippers,* Glasgow.<br>*The Colonial Clippers,* Glasgow.<br>*The Down Easters,* Glasgow.<br>*The Last of the Windjammers,* Glasgow, 1935. Second Edition two volumes. |
| REGISTRAR GENERAL OF SHIPPING & SEAMEN | The Mercantile Navy List, London annually since before since before 1851. |
| SEA BREEZES | Periodical, Liverpool since 1919. |
| UNDERHILL, H. A. | *Deep-Water Sail,* Glasgow 1963. |

## SHIP PORTRAITURE & PORTRAITISTS

| | |
|---|---|
| CHATTERTON, E. Keeble | Old Ship Prints, first published 1927, reprint 1965, London. |
| WARNER, Oliver | *British Marine Painting.* |
| WERNER, Tim | *Kapitan's Bilder,* Rostock G.D.R. 1971. |
| WILSON, Arnold | *A Dictionary of British Marine Painters,* Leigh-on-Sea 1967. |
| VARIOUS AUTHORS | *Art and the Seafarer,* London, 1968. |

# Index

**A**

Aberdeen, 50 80, 114
Aberystwyth, 103
*Acasta*, 76
Ackerman, 59
Adam, E., 30
*Alarm*, 52
*Alcester*, 69
Alfred, W. L., 67, 93
Alice, 94
Altona, 47, 48
*Andromeda*, 16
*Anna Dixon*, 104
Annan, 97
*Anne Duncan*, 85
Antwerp, 37, 47, 52, 55
Aquatints, 85
Arctic, 15
Arpe, 28

**B**

Barcelona, 23
barque, 93, 117, 118
barquentine, 73, 75, 76, 85, 86
Belgium, 52
*Ben Nevis*, 62
billy boy, 33, 43
Binks, Thomas, 15, 16
*Bona*, 36, 101
Boston (U.K.), 106
Boston (U.S.A.), 19, 68
Boyne, J. T., 44
Branden, A. K., 99
Bremerhaven, 50
brig, 13, 16, 30, 61, 76
brigantine, 56, 73, 83, 116
*Britannia*, 33
Brocklebank, F. & J., 69
Bufford, J. H., 60
Burwood, G. V., 112

**C**

*Caesar*, 13
camera, 10, 40
Cammillieri, Nicholas S., 27, 82, 94, 104
Cararonne, 28
Cardiff, 45, 122
*Carisbrooke Castle*, 60
Carmichael, James, 65
*Casma*, 19
*Cedarbank*, 118

Chappell, Reuben, 30 et seq., 74, 119
*Charles Henry*, 86, 109
*Christian*, 17
*City of Carlisle*, 73, 80
*City of Hamilton*, 73, 80
Clementson, John, 21
*Clyde*, 99
coal ports, 44
    —trade, 33, 81, 110, 111, 122
Colchester, 104, 121
Collins, Henry, 21, 73
Commercial Code of Signals, 71
*Compass*, 102
*Corcyra*, 42
Corsini Raffalea, 28
*Courier*, 94
*Craigmullen*, 93
Cunningham's topsail, 115
Currier, N., 29
cutter, Revenue, 14, 76
*Cutty Sark*, 51

**D**

*Daisy*, 33
*Dawn of Day* LT 565, 112
de Clerk, A., 55, 60
D'Esposito, Georgio, 27
Denmark, 23
*Deva*, 93
Dodd, Robert, 59
Dogger Bank, 39
Dover, 80
drifters, herring, 40, 41
    —sail, 40, 78, 112
    —steam, 30, 78
Duncan, E., 58, 65
Dunkirk, 53
Dutton, T. G., 56, 59

**E**

East Coast, 39, 77
East Indiamen, 12
*Earl*, collier, 86, 111
*Edith Eleanor*, 103
*Eilbek (ex Moreton)*, 37
*Eliza*, 99
*Elizabeth Nicholson*, 97
*Elvira*, 49
*Emily*, 58
*Empress of India*, 100
engravings, 58
*Enterprise*, 34
*Erato*, 18

*Essex Lass*, 104
*Esther*, 88

**F**

*Faith*, 113
*Faithful*, 94
Fannen, J., 42, 44, 99
Fedi, Guiseppe, 27, 79
    —Joseph, 27, 61
Fedler, Carl, 50
First World War, 32
fishing, 40
flags, 66 et seq., 67, 77, 88, 10?
*Flamingo GY 1021*, 114
Flensburg, 48
Fletcher, Thomas, 16
*Florence*, 84
*Florence Nightingale*, 86, 111
*Flying Childers*, 92
Fonda, Nicola, 27
Fondo, Michele, 27
*Fortitude*, 79

**G**

galliot, 46
Gavle, 50
*Gem*, 121
*Genesta*, 95
glass-painting, 53
*Glance*, 115
Glasgow, 85, 89, 96, 99
Goole, 31, 74
gouache, 26
*Grange*, 22
Greenock, 19, 69
Gregory, P., 43
Grimsby, 41, 114
Guernsey, 115

**H**

H. H. (Aberdeen), 114
Hansen, B. H., 53
Hansen, D. H., 49
Hansen, Otto, 22
Harris, James, 63, 97
Harwich, (port), 60, 102
*Harwich*, 32, 35
*Haste Away*, 119
Heard, Joseph, 21, 81
herring cargoes, 13, 57, 61, 79
Hodgson, Oliver, 21
Holland, 52

*lt Hill*, 116
*me* Trade, 46
*rd*, 125
*r*-boats, 91
*don*, John, 44, 109
*ggins*, William J., 58
*l*, 14, 15, 16
*mber*, 32, 41, 45
—keel, 119
—sloop, 119
*nter YH 560*, 78
*att*, C. C., 89, 120

*wich*, 24, 75, 79, 82, 120
*strated London News*, 62, 63
*ernational* Code of Signals, 71
*of* Man, 13, 18

*obsen*, Antonio, 51
*nes Bowles*, 101
*nes R. Bayley*, 103
*n Cobbold*, 82
*n Scott*, 81
*1. Kirby*, 89
*hua Nicholson*, 53
*i*, John, 14, 17
*r*, William, 14
*anar*, 107

*drejerbilleder*, 23
*nsington*, C., 51
*tch*, 60, 88
—rig, 74, 90
—barge, 33, 95, 100
*toe*, S. H., 121
*ngs* Lynn, 45, 106, 120
*ell*, W. A., 58
*onborg* Castle, 48, 49

*idman* George, 45, 106
*maetiniere* Alex., 53, 64
*verock YH 314*, 113
*ghorn*, 79
*ngi*, Francesco, 28
*lavre*, 30
*iboat*, 95
*id*, Andeas, 50
*nus*, 82
*n*, 61
*hography*, 58
*erpool*, 17, 18, 19, 69, 88, 89,
93, 104, 117

Livorno, 79
*Loch Lomond A857*, 114
Loos, Henry, 50, 55, 105
Loos, John, 55, 84
Lowestoft, 40, 42, 44
Luck, Kenneth, 44, 78
luggers, 90, 111
Luzzo, Giovarnni, 29
Luzzo, Vincenzo, 21, 25

**M**
Madonnari, 27
Malaga, 28
Malta, 23, 27, 82, 104
*Maria*, 79
*Mary Brack*, 83
Marryat, Capt., 70
Marseilles, 27
*Mazeppa*, 120
McKinley, Charles, 44
McLachlan, M., 45, 122
*Meda*, 86
Media, 27, 29, 34, 53
Merchant Navy List, 69, 71
Merchant Shipping Act, 66, 67
Mersey, 19, 105
*Mindora*, 63
Mohrmann, John Henry, 22, 36,
37 et seq, 53
*Morrison YH 78*, 114
Mowle, 44
Museums, 11

**N**
Naples, 13, 23, 24, 26, 46
Napoleonic Wars, 12, 25, 77, 81, 86
Naturalism, 29
*Neva*, 21
Nevin, 82, 98
Newcastle, 111
Newfoundland, 74, 88
Nibbs, R. H., 14, 17
Norfolk Wherry, 118
*Northfleet*, 67
North Sea, 39
North Shields, 19
Northumberland, 95
Nutter, Henry, 19

**O**
Odessa, 24
*Orwell*, 87
Oslo, 24
Ostend, 53, 54
*Owen Glendower*, 56

**P**
Padstow, 99
Par, 32
Pellegrin, Honoré, 28
*Perseverance*, 105
Petersen, Jacob, 48, 49
Photography, 31, 44, 65
pilot cutters, 53, 90, 105, 106
pilot-schooners, 55, 90
Portsmouth, 17
Poulson, E., 80
*President*, 30
*Pride of Mistley*, 102
*Princess*, 32, 74
Prince Edward Island, 86, 115
*Princess Alice*, 55
*Principality*, 117
Purvis, T. G., 45

**Q**
*Quos*, 67

**R**
Race, George, 41 et seq., 78
—William, 41
Ramsgate, 44, 95
*Rapid*, 83
*Raven*, 9, 116
*Record Reign*, 100
*Red Rose*, 88
*Reform*, 64
Register of Shipping, 66
Registry Act, 66
remuneration, artists, 19, 22, 35,
41, 45, 59
*Renard*, 84
*Rescue*, 115
rigs, sailing ship, 72, 76, 90
Robson, J., 104
Romantic Movement, 19
Rosenburg, C., 58
Roux, Antoine, 29
—Antoine Frederic, 29
—Francois, 29
Royal Academy, 14, 18
*Rozelle*, 96
*Ruperra*, 122

**S**
sails, 72, 87
Salmon, Robert, 14, 17, 19
San Franciso, 37
Schleswig-Holstein, 49
schooner, 88, 91, 102, 106
Scott, John, 92
Seaham Harbour, 121

Simone, J.,
*Sint Johannes*, 46
Sketty, J. C., 59
*Sleet YH 717*, 38
sloop, 87
smacks, 87
snow (rig), 30, 48
*Snowdrop*, 109
South Shields, 121
Southampton, 99, 104
*Southern Belle*. 60
spritsail barge, 60, 119
*Star of Hope*, 43, 45
steam-power, 40
steam tugs, 40, 77, 96
Stettle, W. F., 59
Stewart John, 67
Stockton, 28, 45, 88
style, 23, 29, 39, 42, 48, 52,
    55, 60, 62
stunsails, 76, 89, 103, 109
Sunderland, 22, 28, 42, 68, 83,
    84, 86, 98, 108, 109
Swan, Tom, 38, 42, 78, 113, 114
*Swift*, 120

**T**
*Tagus*, 47
techniques, painting, 35, 45, 53, 55
Tench, E. G., 44, 112
*Thetis*, 51, 54

*Thomas*, 110
*Thomas* (sloop), 98
*Thomas and Elizabeth*, 108
Trading Flag, 69
trawlers, sail, 44, 90, 112
    —steam, 41
Trinity House, 90
*Triton*, 48
Tudgay, F., 50
Tudgay, J. C. L., 51
Tudgay, J. F., 51
Tynemouth, 87, 92

**U**
*Ulelia*, 74

**V**
*Valhalla*, 108
*Vanora*, 98
Venice, 22, 84
Vernon, H. J., 59
*Villata*, 89
*Visitor*, 24
Votive pictures, 22, 24, 75

**W**
Walters, George Stanfield, 18
    —Miles, 16, 18, 76
    —Samuel, 18, 105, 115
Ward, John, 14, 15, 59
Ward, William, 15, 16

Ward-Jackson, C. H., 31
water ballast, 86
water-colour, 27, 34
Webb, W., 80
Weedon, E., 63
Wells, 57
Weyts, Carolus, 53
    —Ignatius, 53
    —Petrus C., 51, et seq.
Whaling, 15, 77
Wheel steering, 84
Whitby, 15
Whitcombe, Thomas, 59
Whitehaven, 14, 19, 21,
    81, 88, 110
Whitham, J., 106
Whitstable, 116
Wilkinson, E., 44, 68, 86
*William*, 75, 85
Willoughby, 16, 77
*Windrush*, 68
Woldings, 88
*Wonder*, 28

**Y**
Yachting, 90, 107, 108
Yachtsmen, 90
Yarmouth, 17, 42, 44, 57,
    61, 64
Yellow-metal, 83
Yorke, W. M., 85

THE ABERDEEN CLIPPER-BUILT BARQUE *PHOENICIAN*